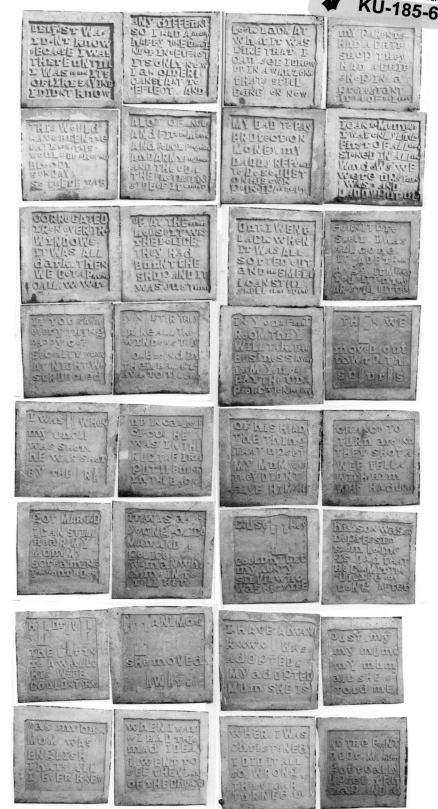

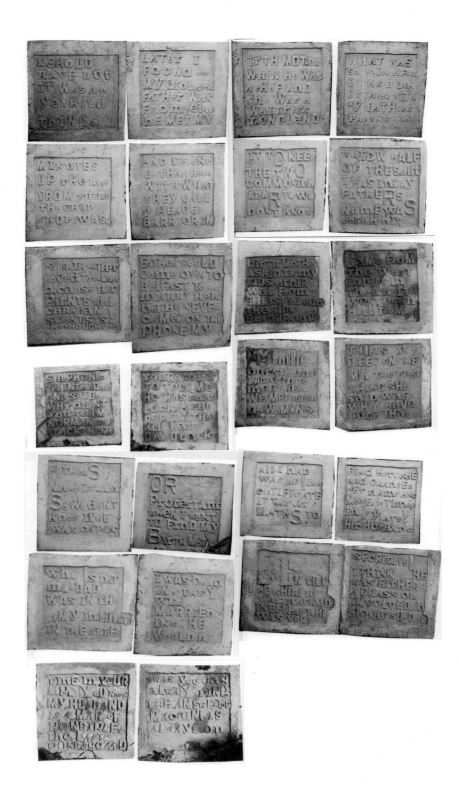

Eileen, 2004.

A YOUNG MAN CAME
TO SEE ME
HE SAID BOB SMITH I
WANT TO MAKE ART.
I SAID 'WHO ARE YOUR
FAVOURITE ARTISTS?'
HE SAID JAMES BROWN AND
LUTHER VAN DROSS. I
SAID THEY ARE INDEED FINE
ARTISTS! BUT YOU MUST NOT
WALK IN THE AESTHETIC SHADOW
OF ANOTHER YOU MUST
CREATE YOUR OWN
REALITY!

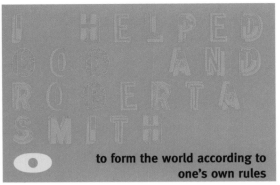
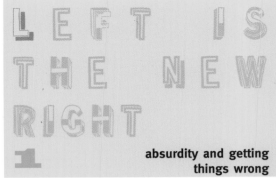

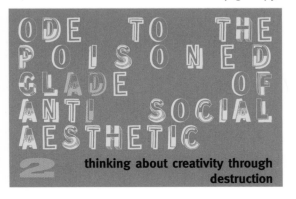
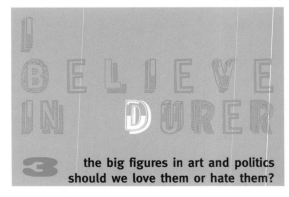

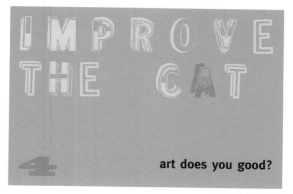

IMPROVE THE CAT

4

art does you good?

POINTLESS

5

objects with no meaning

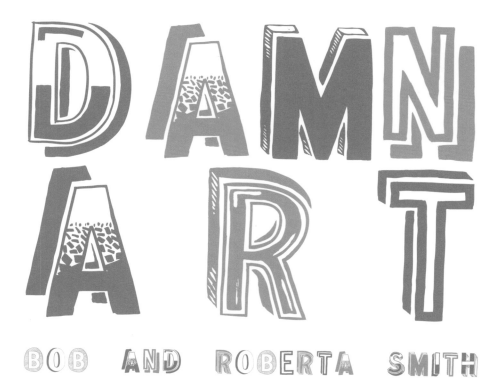

DAMN ART

BOB AND ROBERTA SMITH

I AM SICK OF BEING AN ARTIST I WANT TO BE A POP STAR

6

art and music

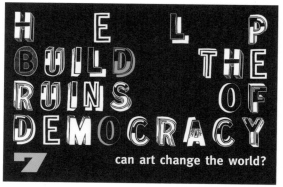

HELP BUILD THE RUINS OF DEMOCRACY

7

can art change the world?

I H E

B O O B

R O O B

S M I T

an introduction by Horst Griese

to form the world according to one's own rules

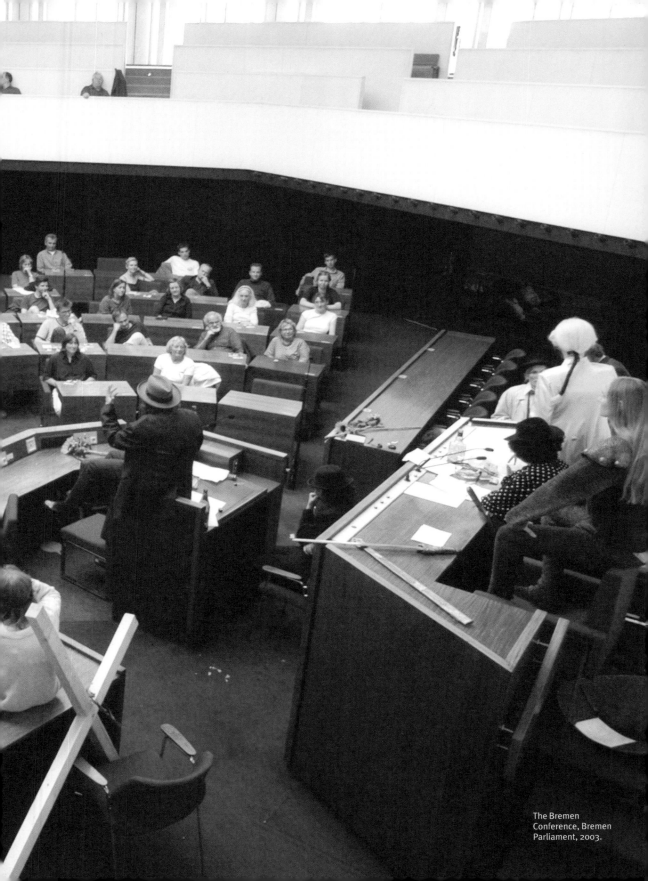

The Bremen
Conference, Bremen
Parliament, 2003.

to form the world according to one's own rules

Make your own damn...!

Don't ask too many questions, just do what's important to you. You just do it! Make your own damn art! The 'damn' has its legitimacy. 'Making' honours the maker but it's complicated because, unfortunately, one can't always anticipate the results. It could come out lacking humour. If this happens, no sympathy will help. In the late 1970s we in Germany for months saved money to buy 12 Land Rovers for Zimbabwe's fight for independence under the leadership of the 'great' Robert Mugabe. Only now can we see the disastrous consequences of this movement. Together we hailed the 'liberation armies' of Pol Pot. Kampuchea should be self-governed! What evil awakening was in store for us! Admittedly, these examples are extreme. Nevertheless, they illustrate how things that seem incredibly clear one day turn twisted the next, distorting everything in their vicinity—the entire context is suddenly turned upside down. Whoever claims that we cannot influence things is wrong. Only, which influence and to what effect?

I helped Bob and Roberta Smith

Chisenhale Gallery, October 1997. Don't Hate Sculpt. I have come here to see an exhibition of Bob and Roberta Smith. But I won't meet the artists, they are not in London. Instead, we meet at the Basel Art Fair. They paint new words such as "putzad", "whodaledo" and "sod". To mark the occasion I am being presented with a badge: "I helped Bob and Roberta Smith write a new language." Since then we have had the opportunity to deepen our acquaintance.

◄ Horst and Inge Griese hitchhike to Aachen, 1970.

The Bremen Conference, Mozart having his wig fitted, 2003. ▶

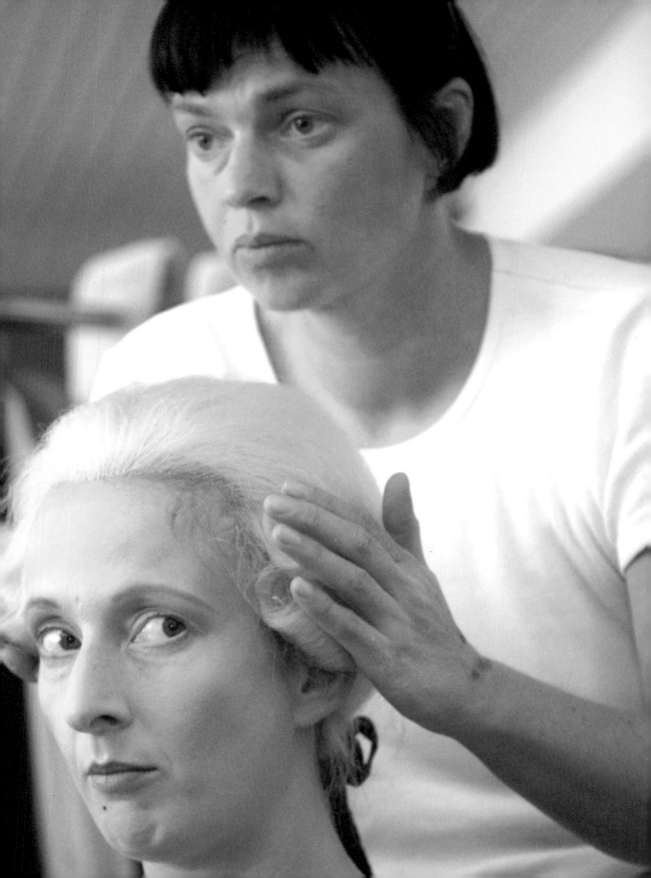

Nine actresses and one parliament

In September 2003 a historic gathering puts the town of Bremen on the map of world-famous conference venues: The Bremen Conference. Bob and Roberta Smith are the creators of this event. Jacques Tati, Bob Dylan, Ritter Ronald (Sir Roland the Lionhearted), Henri Toulouse-Lautrec, Vincent Van Gogh, alongside Martin Kippenberger, Winston Churchill, Wolfgang Amadeus Mozart and Jesus Christ take their seats in the plenary chamber of the Bremen parliament, where usually MPs from all parties deliberate over the city's political fate. Now a different kind of guest is to be expected. Their names, as well as the sub-title of the event: "The most celebrated men in history discuss the problems of today", provoke eager anticipation. It's of little concern that among all the heralded eminencies only Bob Dylan, the chairman, is definitively still with us.

So, what about these renowned men of world history? These 'men' are in fact actresses from the Bremen Theatre – almost the entire ensemble. But what their characters are putting forward seems to be a load of bar-room clichés rather than witty critique. Any attempt at a serious reflection on any of the explosive themes is being nipped in the bud by the actresses' eagerness.

There will be no redemption

The audience is irritated; its ideological needs don't find fulfilment. Their intellectual expectations were not met despite wide-ranging themes concerning gender inequalities, political hotspots, German Reunification and genetic manipulation. Instead, the characters develop a sparkling life of their own and the improvised performance, which lasts just under an hour, alternates between slapstick, living sculpture and theatrical improvisation. Neither the female view on male dominated historical traditions nor the tense subject matters create an interesting breeding ground; they stand in inverse proportion to the actresses' enthusiasm. The happening follows the monotonously delivered questions of chairman Bob Dylan on (bar-room)politics, national prejudice and history as bedtime story. Toulouse-Lautrec slides on his/her knees across the room, Jesus responds paranoid-hysterically to anyone present: "after 2000 years even I am

Lets Not Do Anything, Jeffery Charles Gallery, 2003.

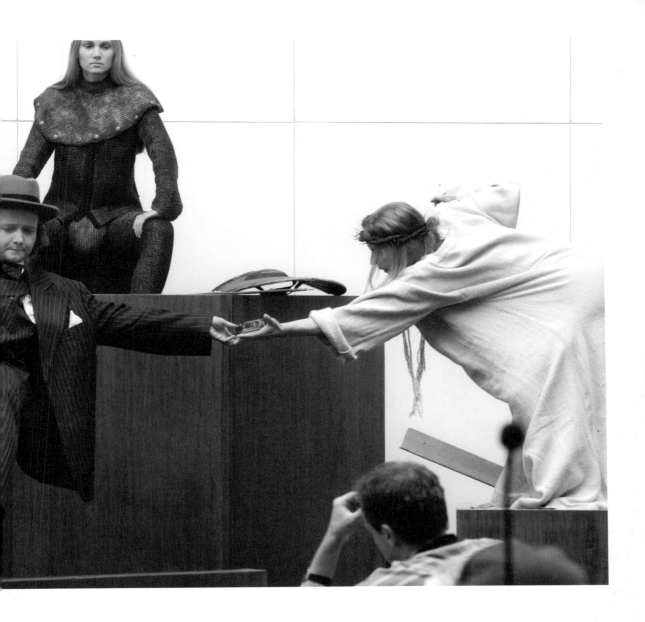

The Bremen
Conference, Jesus
hands Churchill an
ashtray, 2003.

allowed to lose my cool", while Mozart opposes everyone with silent, mischievous scowls. At one point Van Gogh goes completely berserk and Churchill, as a figure of authority, attempts to gain the lead over this pandemonium. Whilst under the influence (someone filled the prop-bottle with real rum!) Martin Kippenberger (alias Wiltrud Schreiner), answers the conference's central question whether conceptual art is utter nonsense: "Conceptual art is nonsense and it makes sense."

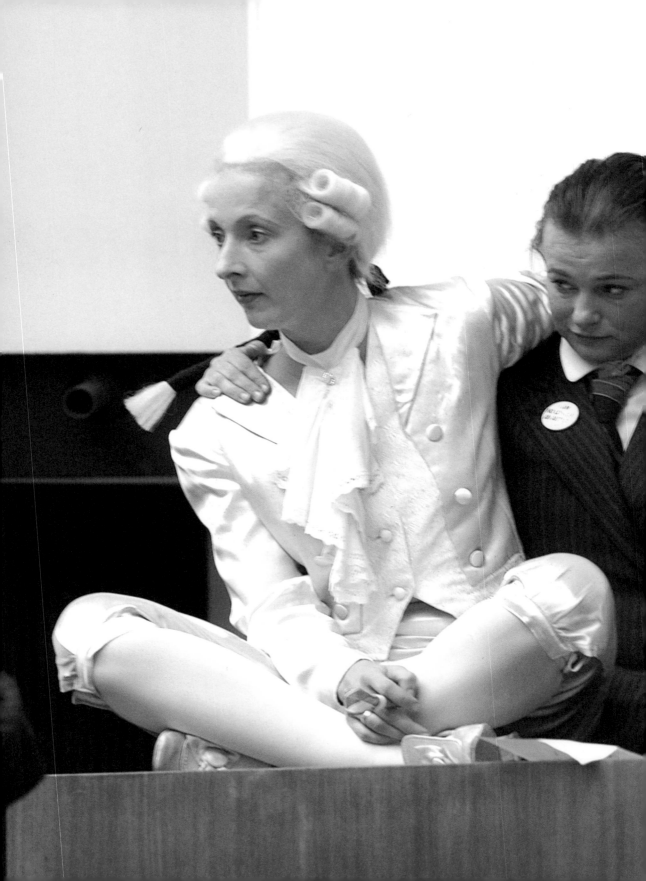

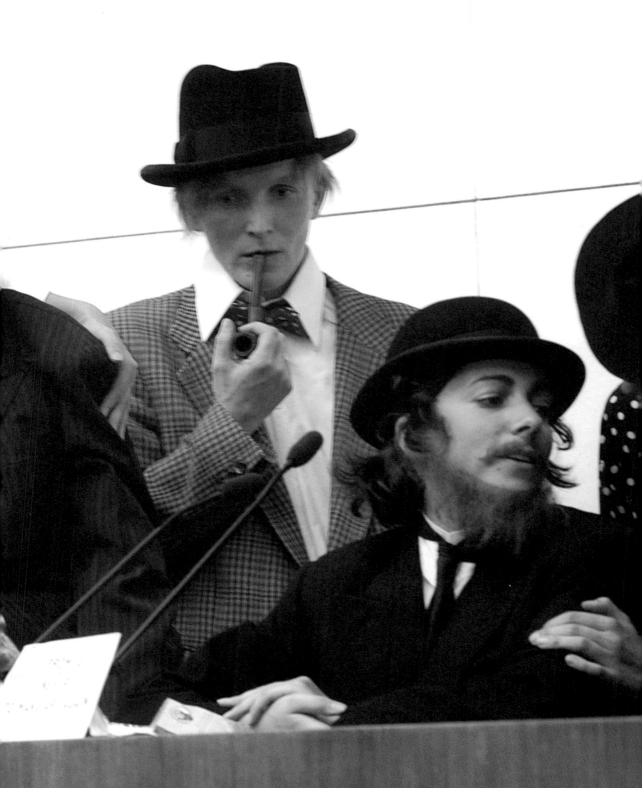

The Bremen Conference, Bremen Parliament. Left to right: Mozart, Martin Kippenburger, Jacques Tati and Toulouse-Lautrec

In that manner the Bremen Conference, Part 2 continues a few days later in the shape of a birthday party for Toulouse-Lautrec, held on a theatre-ship and including birthday cake. The birthday cake's inevitable resting place is Jesus's face thereby forming the highpoint of the conference. Ritter Roland barely takes notice of this though. Armed with his out-sized knightly jockstrap he tirelessly makes pompous advances towards Toulouse-Lautrec. A staunch warrior knows how to behave accordingly.

The bishop's crosier as enema

The manly women occupy the parliament and conquer benches and tables, which bear name plates, cryptic carvings, initials and other traces of use like school desks. Despite being a relatively new post war building – this institution, as well as the history of Bremen's assembly itself, which goes back to 1225, is undoubtedly venerable. The town has a long tradition as a city of free citizens. It received its independence from Kaiser Barbarossa in 1186 and the right of free trade goes back even further to 888.

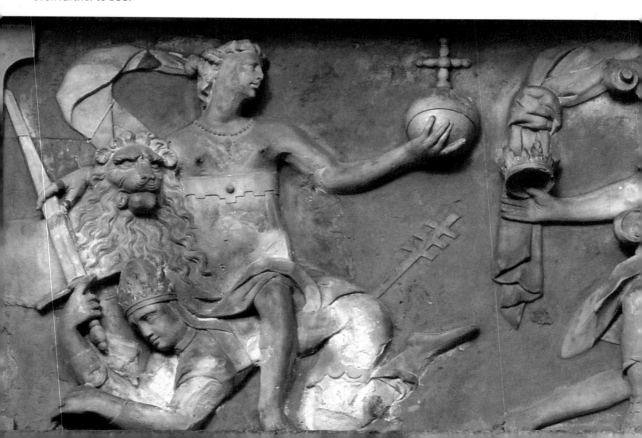

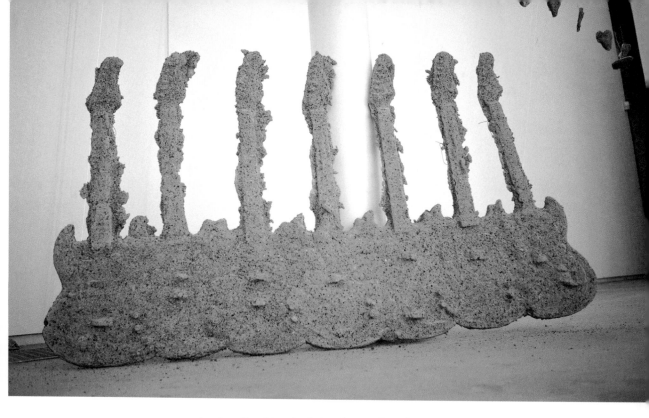

In 1612, the elders had already prominently immortalised their contempt for both ecclesial and secular power in a relief on the town hall's façade. It depicts two allegorical female figures. One of them, who represents the "freedom of empire", rides on an archbishop and tears away the insignia of his power: imperial orb, crown and sword. The other stands for the "freedom that triumphs over constraint" and can be seen stomping on a figure symbolising "blind war". The women have spared the bishop's crosier, but they left it stuck up his ass.

Participation lies in a box

"Hello, I am Dick Scum from the British punk band Armitage Shanks and I love to make sand casts." In spring 1998 this and other posters bearing Dick Scum's visage are spread over Bremen. Calling on people to visit the Sandcasting Centre these posters adorn the trees lining the riverbank that leads to the exhibition space, Dick Scum's Sandcasting Centre. There, a gigantic box filled with sand towers over all sorts of junk. This is where the casts are manufactured, the birthplace for a range of bizarre concrete and plaster objects: an iron-clad guitar with seven necks alongside tattered slippers, a heap of coffee mugs overflowing with plaster, a variety of Barbies and toy guns (sex + pistols!) and other things. In an interview Bob and Roberta Smith say, "The idea is the persuasive thing and not the particular hand of the artist." Visitors have taken some of the objects home;

others have made new ones and distributed them across the space. It is, indeed, easy to put these objects together: squeeze a Barbie into the sand, fill the resulting cavity with concrete or plaster and then wait until it's dry. Any child can do it. At the end of the exhibition the remaining objects are being sold, none knowing or caring who had created them in the first place. A group of elderly rock fans buy the plaster guitar, Bob and Roberta Smith's concrete one proves too burdensome for them. The leftovers are given away, only the heavyweight 7 necked guitar ends on a skip after having been damaged during transport to an allotment (to serve as a climbing frame for tendrils).

The multiplication of the artist
As if there weren't already enough artists, Bob Smith's idea of participation starts with the split of his own self into two; his sister Roberta becomes his constant companion. This dissection of his personality continues beyond his sister to include (imagined or real) family and outsiders. In the 1997 installation Don't Hate Sculpt six acquired 'relatives', folk-artists of the extended Smith family, follow their loves and hobbies: they paint vegetables made out of concrete, rear pigs, cook, paint and generally perform all kinds of autobiographical creativity. Increasingly, Bob and Roberta's projects are populated by people from their

Don't Hate Sculpt,
installation view,
Arnolfini, 1998.

respective neighbourhoods and site-specific fantasies. They use representatives who act in their own name and tirelessly extend 'their family'. Successively, they appropriate the world through adopting its inhabitants. Their concepts create a given frame. These ever-changing sets of rules are then packed with the participants' ideas, material manifestations, actions and statements. In some cases, their improvisations and peculiarities (whether fictional or real) go beyond the artist's intentions and develop an autonomous life of their own, away from any artistic influence. Here, Bob and Roberta's motto "make your own", acts as a catalyst, as an occasion for a new interpretation of reality.

Home-cooked tastes better

Bob and Roberta Smith's 26 Instructions is the title of a poster that demands of its audience a range of abstruse things: "Make coloured rubber sandwiches" or "Dip records in chocolate". Number 11 goes beyond mere instruction: "Invent new things". The process of making helps to define a notion of the self. In its course, the subjective action becomes a potential boundary against a reality that, with its imperious mechanisms, commands unconditional suppression. Bob and Roberta Smith explode the narrow borders of a self-reflexive art context. A review of their work listed characteristics, such as interaction, participation, crossover. These are tired, empty terms, fashionable keywords and, at the same time, they are useless in describing where the essence of this work lies.

Instead, one could talk of a virus. In the case of the Bremen Conference it had infected the city's theatre. A whole machinery of actresses, make-up artists, dramatists, volunteers and patrons of parliament have been contaminated. At first, the actresses cautiously listened to the artist's explanations. What did the audience want from them? Play famous men? But where is the script? Where are the instructions? Make your own! The enthusiasm spreads, but the doubt won't dissipate entirely. Which medication protects us from this virus? The actresses are performing artists, they usually follow predefined roles and don't have to invent themselves. A strong director leads their talents and energies towards a preconceived goal. The Bremen Conference becomes a 'hermaphrodite': Is it still theatre? Is it something completely different? If not, what is it then? What's more, the professional audience is rather clueless. Are the women on stage meant to be themselves, others, or actresses?

⋀ "Forward with the rights of the working class." Wolfgang Reichinaur. Art and Politics were a radical group of artists and typographers who were active in Bremen in the 1970s, and of which Horst Griese was a member, Bremen, circa 1978.

It's good to have hobbies

Bob and Roberta Smith's work cannot be reduced to one genre. Often, it takes the shape of hobbies: music, cooking, doing handicraft work. The artists run a contemporary art centre, the Leytonstone Centre for Contemporary Art, a shed in their garden. There, according to an announcement printed on a badge, the "Fat Cat Manchester Artists meet the Fook Off Cockney Wankers" for a contest. On their friends' website entitled "Victor Mount's trash art-zine" Victor Mount collects absurd ideas from all over. As painters they are interested in typography, coloured letters orderly arranged on classical tableaux. "After Francis Bacon chopped off his ear." By means of a grotesque font they document bizarre rules, proverbs, names and fictional events relating to famous people. Speak Bob is the name of an interactive digital sound construction of a widely unknown language whose formation of sounds follows your own arrangements. As a musician Bob is similarly intriguing. Together with the Ken Ardley Playboys he released two CDs and a few singles, such as "I'm sick of being an artist, I want to be a popstar". Bob and Roberta Smith suggest that every artist needs a hobby.

They carry their lot with humour. Laughter comforts. And it is subversive. Those who have no power can at least laugh about others. This energy demolishes established values and respected authorities. Here are a few quotes from Bob and Roberta Smith to illustrate this point: "Humour is human and things that make me laugh are very important in my work because it's a very profound emotion. One aspect of humour in my work is quite serious, like most humour it has to do with humiliation. The kind of humour which turns me on is always very blank, comedic performances where things go a little bit wrong not because they're funny but more because they're human."

◄ Thank You God For
Wheatabix, 2004.

Art as a way of life

In the face of manic art production one thinks of Joseph Beuys' 'social sculptures'
and his ideas of participation, or of the performative, participatory positions of
Fluxus. There, art was being spelled out as a way of life. It's just that artists of
today (and I would count, for example, Jeremy Deller and his collection of pop-
cultural expressions of mass taste amongst these) have lesser difficulties
accepting the industrially influenced (mass-)cultural trash which had posed a big
problem for the previous generations despite the openness of their concepts.
Make your own damn art contains a subversive encouragement that undermines
reality and that can also be understood as:

Make your own rules!

Make your rules and try them out, regardless of where you might find yourself.
That's how you can turn a parliament into a stage and seduce an entire theatre.
The town is field and pitch to your game. Bob and Roberta Smith first showed in
Bremen in 1998 in an exhibition entitled Do All Oceans Have Walls, inspired by a
Laurie Anderson song. In this song, a dolphin swimming in a pool and never having
experienced anything but imprisonment asks about the borders of his habitat. The
walls are in your head, they exist in your perception, in your subjective actions.
Change the perspective and the territory and the field of action will change too.
Five years later, Bob and Roberta Smith took part in Niemand Ist Eine Insel (No
Man Is An Island). This exhibition was centred around artistic positions that
suspended the process of individualisation, strengthened cooperation and
encouraged communication. At the same time these are fundamental aspects and
characteristics of public discourse and its production and, therefore, of the
multiplication of ideas. The view from island to island relativises distance. Even
continents rise from the waters. Make your own rules!

YOu
ARe
NOt
MY
BRain

LEF

THE

RIGHT

1

IS
NEW

a conversation between Bob and Roberta Smith
and Matthew Collings

absurdity and getting
things wrong

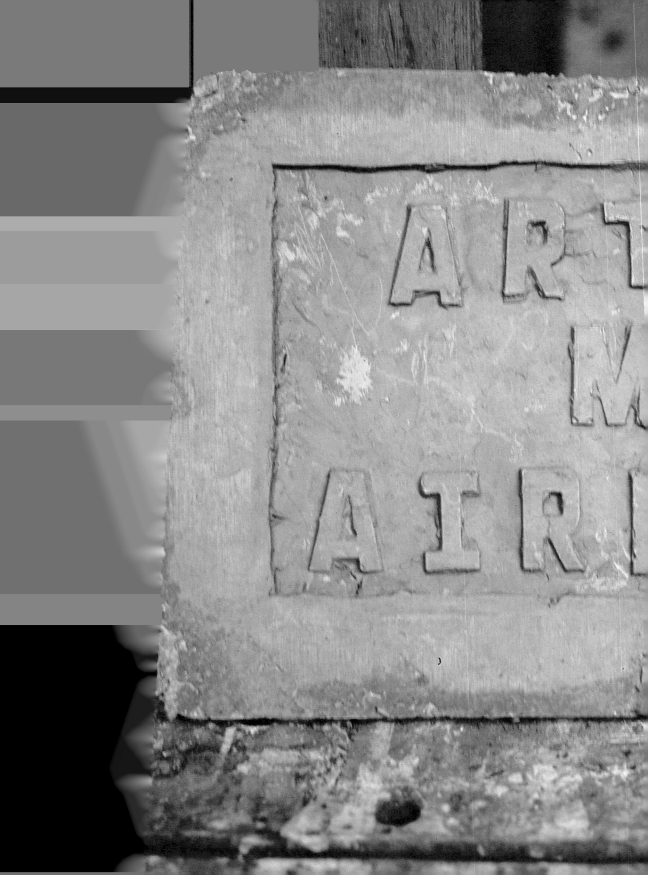

absurdity and getting things wrong

Matthew Collings Do you think the art world can cope with absurdity at the moment? Contemporary art people on the whole lead self-indulgent lives. They're incredibly shallow. They're terrified of not being thought of as up to date. They feel anxious about the reality of all that and they want to escape from the anxiety by a charade. They pretend to themselves that they are serious not frivolous, and responsible not selfish. But anyone not actually playing along can see immediately that it's fake.

Bob Smith Well, I suppose the answer to your question would depend on whether you thought absurdity was self-indulgent. I think it's moral to be absurd. The world is really absurd. The things that we get up to — politicians and everything — are so crazy that embracing absurd things is somehow an area of sanity. People might think it is irresponsible, but that's not my take on it. Because we're patronised, aren't we? We're patronised by people telling us things work in certain ways. You have to take on board all these orthodoxies that you're taught at school, and that beats creativity out of you.

One of the big things that I really liked as a kid was *The Prisoner* TV show. In *The Prisoner* there is a reversal of how normal narrative runs. *The Prisoner* character is in a position at the start of every episode where he's in a bit of a disaster because he's trapped in this Port Meirion surrealist hellhole, and then he has a plan to get out. He executes that plan — and they're quite loony and mad plans — but then, suddenly, it all gets clamped down again by a large white beach ball. It's a bit like the Cohen brothers' films. In particular, one brilliant film,

Concrete Record, 1995. >

< Father Xmas Is A Nazi, still from BBC3 short film, 2003.

Yeah, I'll show you the life of the mind.

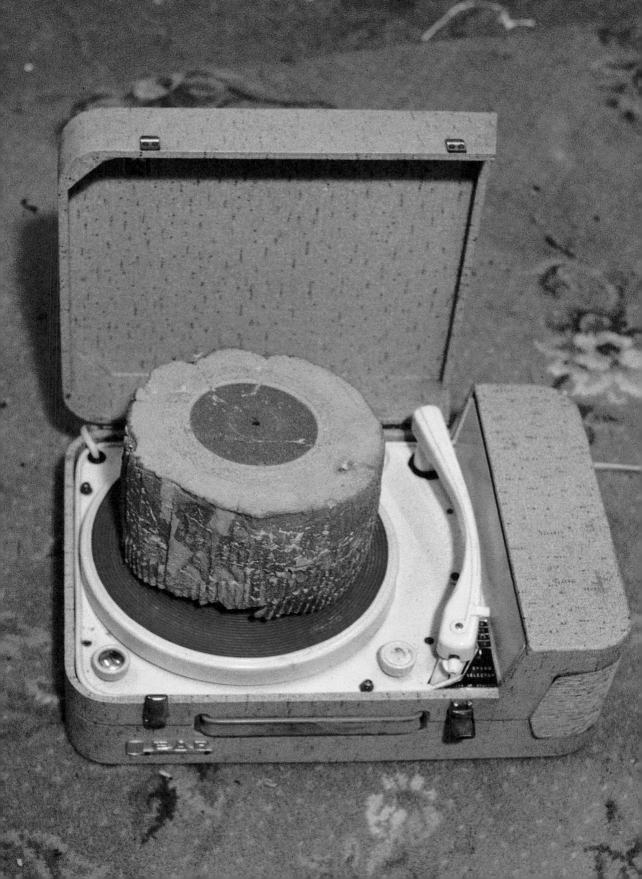

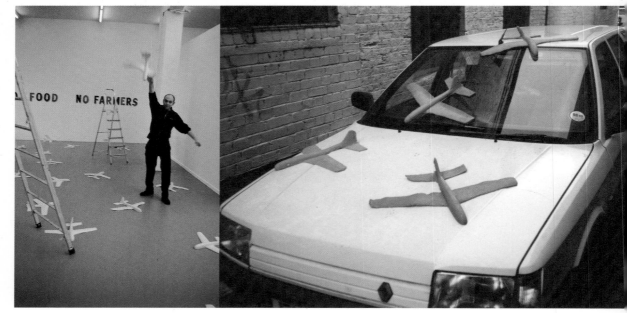

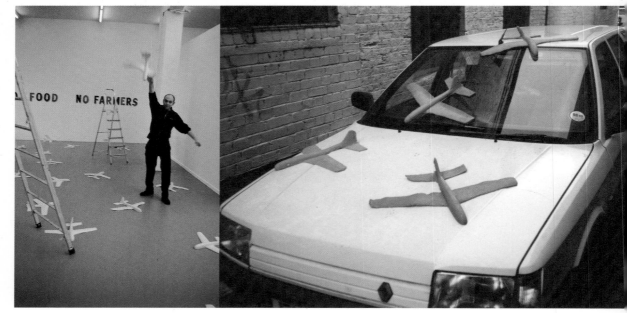

△ Rubber Aeroplanes, the public are invited to throw rubber aeroplanes in the gallery, Migros Museum, Zurich, 1999.

△ Rubber Aeroplanes, 1999.

Barton Fink, where there's a rather patronising artist/writer person staying at a hotel and he befriends John Goodman's character (Charlie Meadows) and tells him all about his project, which is to find out the true life of the mind....

M Yes, he doesn't realise how patronising he's being to the Goodman character, who's a kind of Everyman who's been driven over the edge. And in the end the Goodman guy is surrounded by flames and death and is actually screaming the phrase, "I'll show you the life of the mind! I'll show you the life of the mind!"

B Yeah, I'll show you the life of the mind. And that is really how I view a lot of what I do. I'm quite a mild mannered person, but inside there is this raging loony anger. I really identify with those kinds of characters. It's not to do with morality exactly, but it is to do with expression, the feeling that you've been dumped in the shit, and doing things that are slightly nutty and strange, or idiotic, seems to create a bit of a space where you can operate.

M There's this world of absurdity that you've created for yourself, reality askew. But to get the detail, to understand the joke of what you do, one has to look at your relationship to the art world. It feeds you structures. One

... driven over the edge.

I fantasise about smashing the art world up...

structure is conceptual art and another one is the professional gallery system. Another one is the chat that the art world must do all the time in order to justify itself, so it can believe it not only exists at all but that it has a worthy purpose. And you take all those and insult them, distort them, make them go wrong. And in your work they are still clearly recognisable, that is, to anyone who has had any experience of the art world. It's just that you're being foolish with these creeds, beliefs or systems, instead of preposterously grandiose. Or, you're being amusingly grandiose, instead of sanctimoniously grandiose.

B The art world exists like a theatre. It's a set of parameters to beat up and kick and try and annoy. I fantasise about smashing the art world up and starting again. One of the things that really annoys me about the art world, which is also the world in general — and I'm using the art world as a foil for this — is a kind of class war thing. I think middle class artists should be locked up for a short period, maybe six months. That would prevent the excesses of grandiose thinking. No more Angels of the North. I want to stick pins in Art as if it's a votive figure, a votive figure for the world. And by kicking it, maybe I'm kicking the world, in some kind of way. I'm also entertaining the art world in a court jester sort of way. The Leytonstone Centre of Contemporary Art is like a little model of the art world.

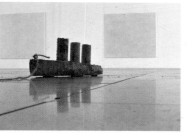

Make Boats, concrete boats made by the public, Kunstverein, Trier, Germany, 1997. **∧**

No more Angels of the North.

Make Boats, The Serpentine, London, 1994. **>**

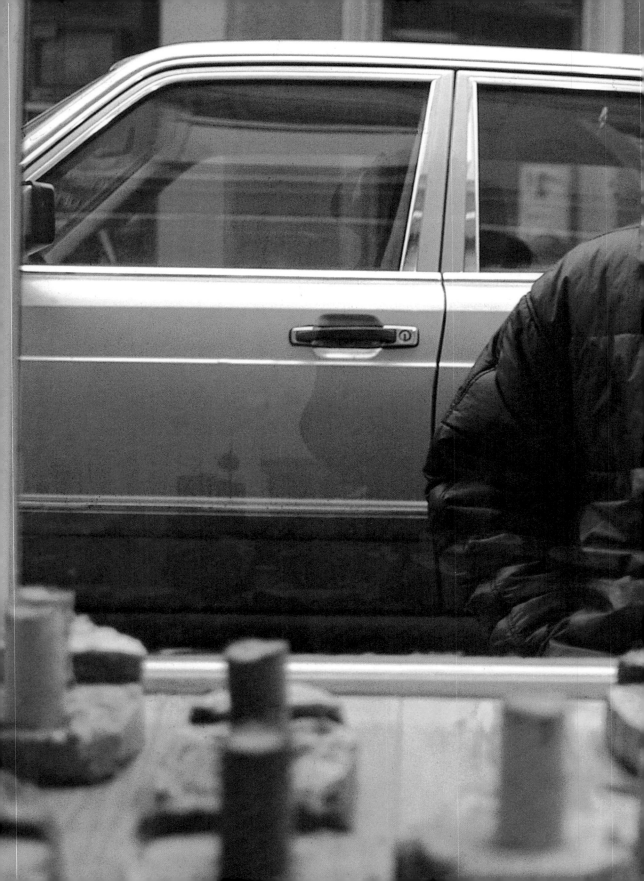

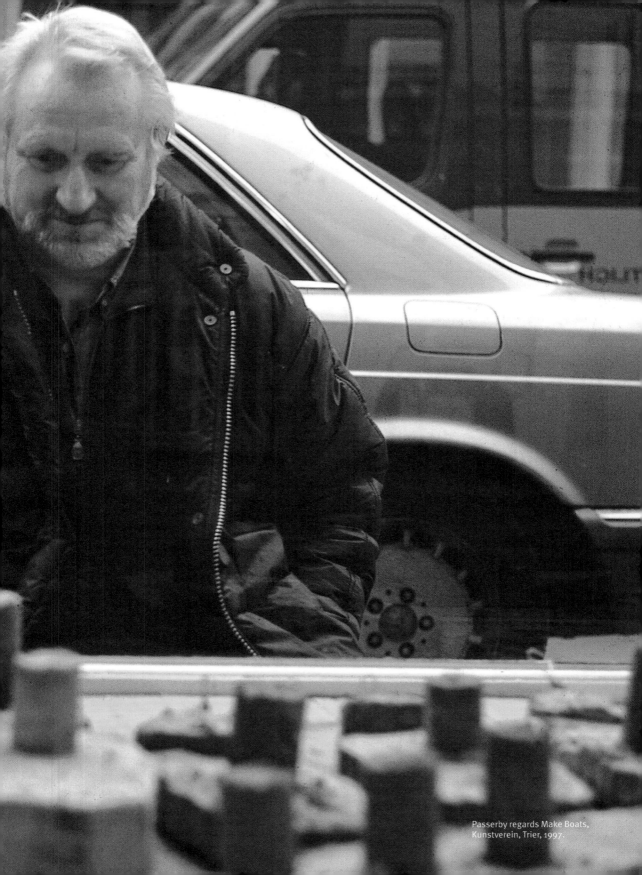

Passerby regards Make Boats,
Kunstverein, Trier, 1997.

Leytonstone

Stuart Taylor's contribution to Fight, LCCA, 2002.

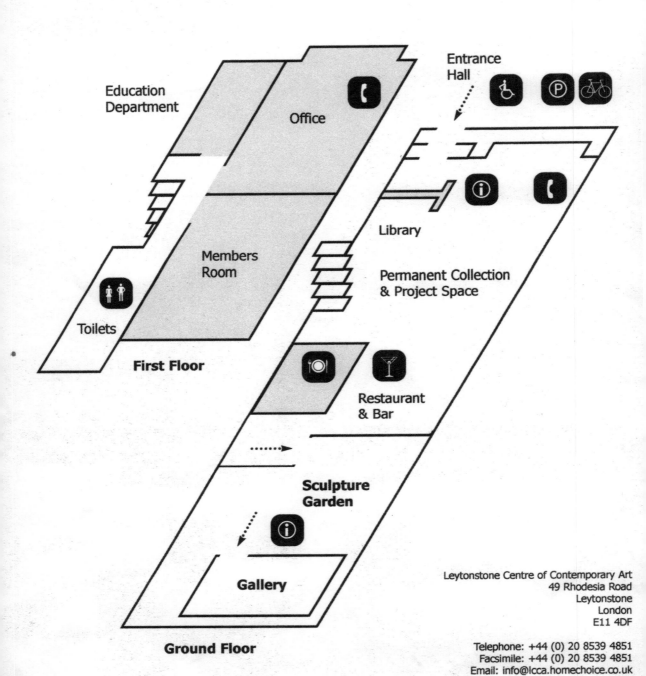

Education Department

Office

Entrance Hall

Library

Members Room

Permanent Collection & Project Space

Toilets

First Floor

Restaurant & Bar

Sculpture Garden

Gallery

Ground Floor

Leytonstone Centre of Contemporary Art
49 Rhodesia Road
Leytonstone
London
E11 4DF

Telephone: +44 (0) 20 8539 4851
Facsimile: +44 (0) 20 8539 4851
Email: info@lcca.homechoice.co.uk

I want to stick pins in Art as if it's a votive figure.

⋀ Another Disappointment, installation view, Anthony Wilkinson Gallery, 1994.

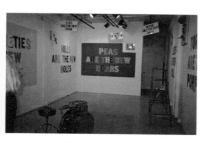

⋀ Birds are the new fish, installation view, Peirogi 2000, New York, 1999.

⋁ Fight, group show of artists from Manchester and London where the public were invited to vote out works they don't like, LCCA, 2002.

BOB & ROBERTA SMITH'S at home installation is;

a) ALRIGHT
b) REALLY BAD

Bring this card with you and circle the statement you most agree with. Every completed card receives a free gift from Bob & Roberta.

Your name ..

24 - 27 February 1994
Private View: Wednesday 23 February 6 - 8.30 pm

Presented by **Anthony Wilkinson** Fine Art
at **The Eagle Gallery**
159 Farringdon Road London EC1
Tel: 071-833 2674 / 071-831 4269
Opening Times: Thurs/Fri 11 - 6pm Sat/Sun 11 - 4pm
or by appointment Tel: 071-831 4269 / Fax: 071-831 9014

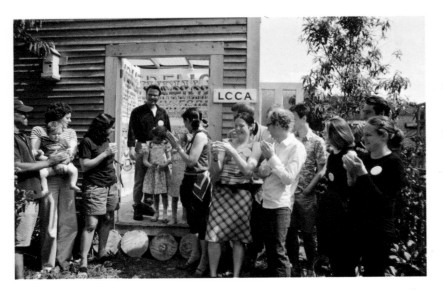

◁ Joe Amrhein at his opening at the LCCA, 2001.

M Yes, it's a good invention. People can make their way out to Leytonstone, if they want, if they can stand it, and spend a day at an art centre. It says LCCA on the door. It's a shed at the back of your garden in Leytonstone.

B I charge 15 pence to go in there on the weekend. I try and do the best shows that I possibly can there, and try and do things that are interesting. The first show that I did, I really liked, was a Joe Amrhein show. Recently, I went to America and I met this collector of Joe Amrhein's work, and Joe introduced me to him as the Director of the LCCA. This bloke went, "Oh it's really great that you gave Joe a show in your institution." And I said, "Yeah, we're really proud to have given Joe his first one person show in Europe." He didn't know the LCCA was a shed. So, it has all sorts of amusing possibilities. But at the root of it is an idea about making your own culture, and making something happen. Even if it's on a small scale, it can have strange ripples.

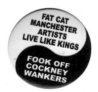

▲ Promotion badge for Fight, Manchester artists vs London artists, 2002.

... power gurus in the art structure.

M I think your work is structured and thoughtful and rather intellectual – you play games with language and concepts. But I appreciate a sort of old fashioned creative side to it too – you mentioned 'expressive' earlier...

B A lot of the techniques that I employ manifest themselves in a kind of conceptual art rhetoric that can be read easily by people interested in art. But, actually, I think there's this kind of central ragingness that I feel about art and life. I really like Buñuel and those kinds of films, but in another way I like Pollock and Guston, especially Guston's later stuff, because he got better and better as he got older and older, unlike most artists. The idea of a sort of expressionism is good, although it is not the current fashion.

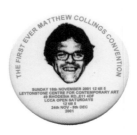

▲ Promotional badge for the first ever Matthew Collings Convention, LCCA, 2001.

A Promotion badge for
Critical Prose, LCCA,
2001.

M Buñuel shocks the bourgeoisie in a way that has now become an official *raison d' etre* of the art world, so it isn't very shocking when it happens.

B He was very funny though.

M Very funny, yeah, and obviously, as well, a very important milestone in the history of meaning, thought, revolution, or whatever. But Pollock and Guston are more about manual skill, flourish, touch, a context of creativity where there's some aesthetic loveliness – plus a bit of a raging macho vibe. These are things that the audience for art nowadays is not so sure about, because it hasn't been inducted into how to appreciate that kind of thing, only into how to find it trivial and dismiss it. Recently, I decided not to like Guston as my political protest against this mindset. I realised there's something appalling about the cult of Guston. Instead of lining up to piously repeat along with everyone else how 'brave' we've personally discovered

Garavacci Was The
First Artist On Urth,
He Did Scribbles,
2003.

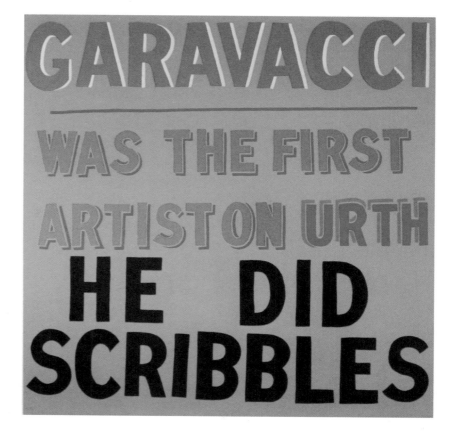

THE LEYTONSTONE CENTER FOR CONTEMPORARY ART

ESTABLISHED 2001

PROVIDING
New ART
TO THE PEOPLe of
LeyTONSTONE

OTHER THINGS

VISIT THE

BR

NEA

'CONF

by Terence

ED HITCHCOCK

MOSAICS
and the
BUS SCULPTURE
LOCATED
E TUBE STATION

T

SION' 1995
on blake hall
d

HOW to get There?
leytonstone tube
central line

LCCA

49 Rhodesia Road
Leytonstone
E11 4 DF
tel 020 8539 4851

LCCA information
leaflet, 2000.

NOKTERNAL ANIMALZ
SLEEP DURIN THE
DAY

PETER SKOTT PAINTS BIRDZ
TERENS CUEO PUTZ A MOWSE
IN EVERY PANETIN AND
ALFRED HITCHKOK APEARED
IN ALL HIS FILMS AND
SO DID MARYLIN MUNROW

BURROWIN ANIMALZ
SLEEP BENEEF THE
SURFACE

THAIR WILL BE
NO SPACE STAISHUNZ

JON LENON AND PAUL MARKARTNY
WROTE MOST OF THE BEETLES
SONGS

THE MAL STARTZ AT ONE END
WITH BUCKINHAM PALACE
AND ENDZ WITH
TWAFALGAR SQUAIR

TOGETHER DAMIAN HERST AND
JAY JOPLIN HAVE BEGUN TO
ESTABLISH AN INTERNATIONAL
REPUTASHUN

MAN KANT FLY

WHAIR AS CARZ IN THE THIRTIES
AND FORTIES WER PWEDOMINANTLY
PAINTED BLACK TODAY THEY CUM
IN MANY COLORZ

OSCAR WILD WOZ GAY

A GAS HEETED RADIATER
IS MOR EXPENSIV TO
INSTAL THEN AN ELECTRIC
FIRE BUT CHEEPER TO RUN

NEFER TRUST A LIAR

DANNI MINOGUE IS
HETROSEX

TIRED PEEPAL
SLEEP LONGER

ON LAND THE PINGWIN IS
CUMBERSUM AND UNGAINLY
BUT IN WATER FLYZ LIKE
LIKE A BERD

I've got a 12 year old Citeroan GSA with insurance I cant afford

31 years its taken to get this tar

A BAD DETECTIVE PROMOTION

"THE KEN ARDLEY PLAYBOYS"

We're the Ken Ardley Playboys cos we can Ardley Play Boys

GO TO HALES SALLEY NEXT WEEK

... out of control
sleazy ad-man
selling bullshit.

him to be, couldn't we notice instead that he's a bit of a schmaltzy people-pleaser? Was he really so brave to change his style when his style had been out of fashion for ten years?

B I did a sign that said "GUSTON IS A MONSTER".

M He's a monster of American boringness. In his interviews he seems the same as Bill Viola. He just talks all this out of control sleazy ad-man selling bullshit. And his freedom nonsense, the freedom to do cartoons, is all too easily compatible with the nowadays art world. Whereas with Pollock, I don't think people in the art world at the moment have the faintest idea what it is he does. They want to acknowledge him because they think Rosalind Krauss has written importantly about him, or Benjamin Buchloh might have something sonorous to say about him in connection with something else that they think confirms the sentimental video art of nowadays.

So where does this leave you? In my opinion, the way you put things together as objects is very nice. You have a sympathetic shabby aesthetic that reminds me of art. When you paint the words PEAS ARE THE NEW BEANS I see something subliminally aggressive to the contemporary art world, something truly ghastly and terrifying for anyone who wants to appear up to date – a kind of St Ives-Ben Nicholson tastefulness. Only, it's cast in a kiddy colour range, instead of the colours of slate and sea and sand and English weather and so on.

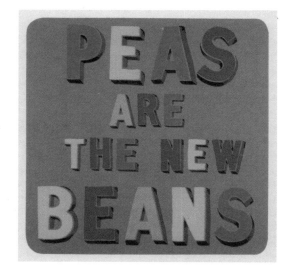

◄ Workings out for
Matthew Higgs'
Imprint book project,
1995.

Peas Are The New ►
Beans, 1995.

Men Are Women, original plaster
cast, 2004.

I think about the colours.

B Don't go there. Well, I think I'm involved in a psychedelic/schizophrenic battle with that all the time. Because it's a useful thing to kill off. My work is very aesthetic. I think all the things I produce are beautiful. But it's a dialogue all the time whether to go with that. I think about the colours. I hate myself for it. It's because I did painting at university, and I suppose it's all of these thoughts... mixed up with my dialogue with my dead dad.

M Your father was Fred Brill, a realist painter who taught at Chelsea art school.

B Yeah, so there's all that going on as well. I tend to talk in anecdotes, but one of the things that is going on is that I lived in Mexfield Road, in Putney, when I was growing up and around the corner, on Manfred Road, was Bill Culbert.

M Didn't he do light bulbs? Is he still alive?

B Very much alive.

M I remember him as a figure of the 70s, was it?

B Yes, he's great. Anyway, he had a house in France, and a lot of very groovy blonde haired children, and he was married to a German woman. And I went to school with his kids. My experience of art as a young kid was really aesthetic, really to do with painting, being taken to the National Gallery on a Saturday afternoon. But then I'd go and hang around at Clay's house – Clay is Bill Culbert's son. And they'd all be smoking dope and listening to John Cage. And he'd have odd bits of fibreglass conceptual art sculptures, which were left over from some show he'd just had in the late 60s. And, so, that dialogue is always there for me. That, somehow, was a way out, to go round to Manfred Road and get away from the pipe smoking, Norfolk jacket wearing, pondering of my dad.

M You get out of the musty brushes and palette-infested house, the turpentine-stinking atmosphere, and go round to the brilliant conceptual art raves?

Private view card for **>**
Floored, Anthony
Wilkinson Gallery,
1994.

∧ Postcard given away at MA degree show, Goldsmiths, 1993.

B Yeah, it would all be groovy round there, and you could almost hear their groovy music across the street. So, that has been there with me a lot, this kind of dialogue, caught between these two worlds. A lot of artists are caught in that sort of world. A lot of painters try to put on groovy music while they ponder, but these days it doesn't work.

M I certainly think it's not acknowledged enough in, say, *Art Monthly* – how we all know about the showbiz angle of certain types of art, but we don't ever like to mention the angle exists. There's a sort of vibe to a certain type of art, and you don't have to be that involved with the depth of the thing, you just have to tap into the vibe. Having depth is now replaced by giving interviews, in which you say roughly the right phrases that you've heard someone else say or you remember reading somewhere. There could be all sorts of reasons for this. Maybe it's cynicism. But regardless of what its moral value really is, it's a sort of mental capability that we now possess.

B I think there's another thing going on now with the *Art Monthly* discourse, which is quite hard to define, but it's quite dry, quite worthy, well-meaning and interesting actually....

M Yeah, it's well-meaning quality is good, I agree, if you abstract just that bit out from the rest – mainly from the suspicion that hardly anything real is meant at all. But in any case it's left wing and it's socially responsible, and it wants to do good, and it looks at society and it wants to say, "What would be good for society?"

B I think people now, young students and artists, what they want now, instead of spaces like City Racing and Bank, all those kinds of entities, is a mini, commercial gallery to show all their mates' work. But it means all their mates' work tends to adopt actually quite sensible values of trying to sell something. And it means the work is not that loony or impracticable. I think the impracticality of what I do and the possibilities for art are really interesting and exciting. The *Art Monthly* thing does cater to that idea.

MAKE YOU|

Bob Smith i|

Chapter One|
Left is the ne|
Absurdity an|

Matthew Co||
Don't they a||
purpose, so|
indulgent arti|

Bob Smith W|
self-indulgen|
that we get u|
things is som|
not my take|
people tellin|
orthodoxies|
and allows p|
that I really li|
reversal of h|
start of every|
Port **Meirion**|
plan — and t|
clamped dow|
films. In parti|
artist/writer p|
(Charlie Mea|

Address: @ http://www.bbc.co.uk/arts/multimedia/guestartists/a_smith.shtml

Back Forward Stop Refresh Home AutoFill Print Mai

@ Live Home Page @ Apple @ Apple Support @ Apple Store @ .Mac @ Mac OS

Favorites History Search Scrapbook Page Holder

B B C Home TV Radio Talk Where I Live A-Z Index

LEARN TO S|

CLEAR STOP

DRAG THE CHARACTERS ONTO THE LINES AN|

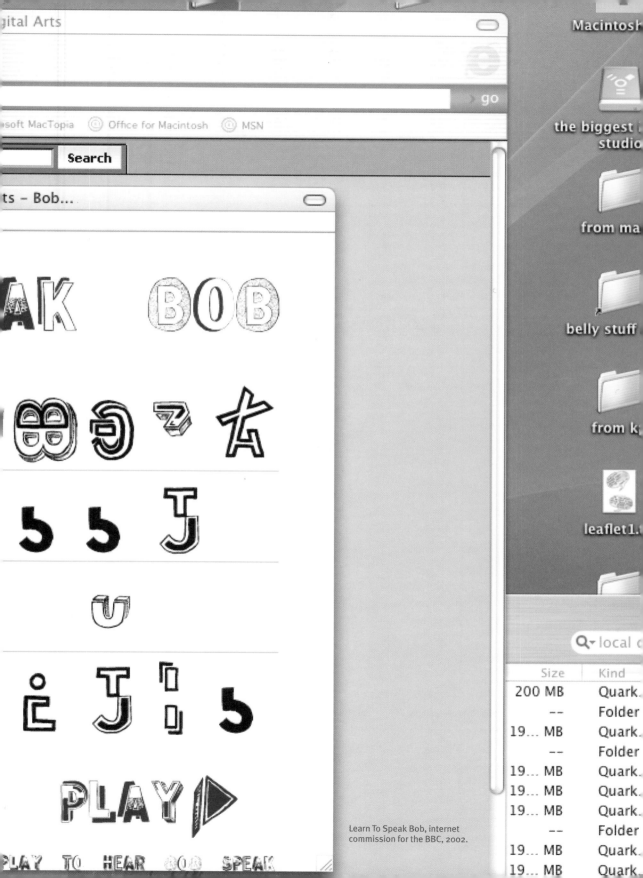

Learn To Speak Bob, internet commission for the BBC, 2002.

"Quish Pet" and "Succo"...

M I think of it as more blindly solemn. There's an *Art Monthly* language you have to speak and you won't be taken seriously if you don't speak it. It's a quasi-academic language, not the real thing because that would involve too many footnotes, but a resonance or feel of art historical academia and theory academia. You have to learn that language. Which leads us to Learn To Speak Bob.

B Learn To Speak Bob is an internet site that you can go to and click on all these different symbols, and each symbol has a different noise/sound, which is me using my throat. It's very much a re-model of a Kurt Schwitters piece, where he did a sort of opera of the mouth. My noises were the names of all the unfortunate kids in our village who were members of the Pounder family. The Pounders were a big family, there were 11 of them, and seven of the Pounder children were OK, but four of them had hunch backs or limps and one was a downs syndrome child, and they all had terrible names. They all had nicknames.

M Hunchy and Limpy?

B They were Ticklemouse, Tic, Nidder, Duck, Nid, Mouse, Hutch. The girls didn't have nicknames because they weren't part of the nickname gang. Then, they'd also use slang. For example 'penis' was 'barngitter'. And they'd use broad Yorkshire-speak, with things like "aye up" and "now then". And North Yorkshire 'farmer-speak', like, to their cattle, like "Quish Pet" and "Succo". So, if you click on the icons you can make those symbols into a sentence and 'play' it. And it goes, "Aye up, Hutch, now then, barngitter barngitter, barngitter, Aye up, now, Nidder, Nid, Nidder."

M Do many people go on the site?

B Oh, yeah, it's been quite popular. It was commissioned by the BBC. Strangely, this Korean museum really liked it. Anyway, they had it on in their gallery, and it was great. When they had it in their space, they had it as a huge projection. You could touch a screen and the letters would go up on a video projection, up on the wall, and then you'd get this North Yorkshire "Aye up" in Korea.

Concrete Kitchen, 2002.

... a gross distortion of the teachings of Joseph Beuys.

M What do you think is the content of Learn to Speak Bob as opposed to its mechanics?

B Well, the content is an ongoing journey, trying to get people to do things, and to involve them in something. So, the content isn't actually the work. The content of it is...

M ... interactivity?

B Yeah, somebody wandering into this museum, touching this thing, and that's the punch-line, if you like, of the joke. A lot of my work operates in this way. Inviting people in – it's only when they do something that it comes alive.

M It's a consciousness-raising thing? The work is a mechanism that triggers consciousness? It points to personal empowerment, to 'doing' as opposed to being always 'done-to'. "People – you can do something for yourself!", even if it is only in an absurd play situation.

B And it might be monitored; you know you might tell that that has happened because somebody laughs.

M The jackpot.

B Yeah, that hits the jackpot. The laughter is the thing that gets people going.

M Tell me about Le École de Burrows and Bob Smith.

who's the leader of the gang

that's made for you and me?

J.O.S.-E.P.H

B.E.U.Y.S

Joseph Beuys
Joseph Beuys
Joseph Beuys
Joseph Beuys

He's the leader of the gang
that's made for you and me.

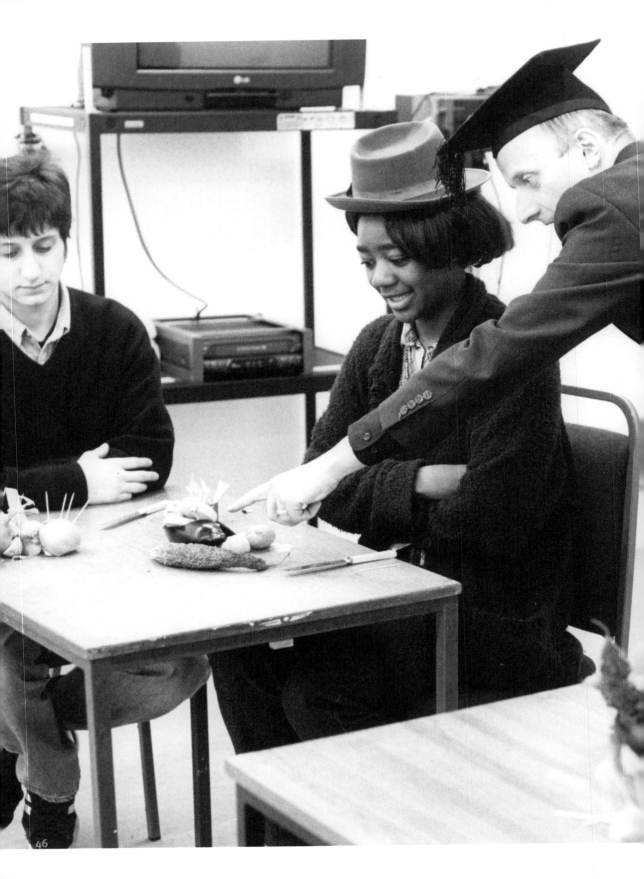

... playing a dangerous game with triviality.

◄ Bob Smith ridicules a
student at Le École
de Burrows et Bob
Smith, 2000. 47

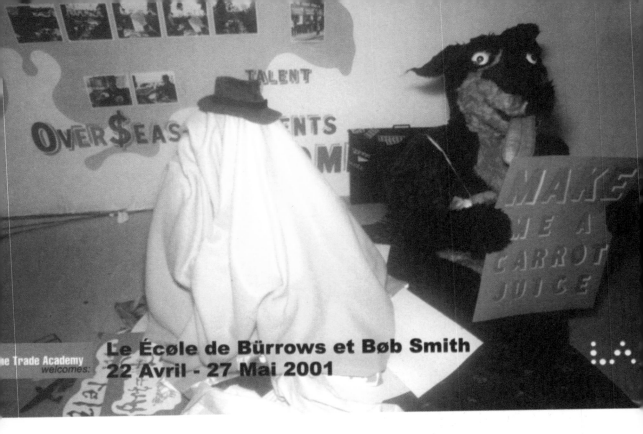

Le École de Bürrows et Bøb Smith
22 Avril - 27 Mai 2001

The Trade Academy
welcomes:

B David Burrows and I have this art school and we invite people to partake in it. But it's a very strict conceptual art school. It's based, a lot, on a gross distortion of the teachings of Joseph Beuys. There is a photo of me marching the students through the school and they're singing:

who's the leader of the gang
that's made for you and me?
J.O.S.E.P.H B.E.U.Y.S
Joseph Beuys Joseph Beuys
Joseph Beuys Joseph Beuys
He's the leader of the gang
that's made for you and me.

I get them all to chant that as we march around the space. We've had shows, and we've done performances. One of the performances was where we re-enacted Joseph Beuys with the coyote, America Loves Me And I Love America. I was dressed up as the coyote and David was Beuys. We did that as a Big Brother video, as well, where the coyote and Beuys are in the Big Brother house. They've been given food and stuff to keep them going, and the coyote's getting very pissed off with Beuys. The coyote is a vegan, but Beuys keeps offering him sausages.

The Coyote is a vegan, but Beuys keeps offering him sausages...

Fruit Box Coffin being
tested in the grounds
of the LCCA by Mel
Brimfield, 2002.

Private view card for
Le École de Burrows
et Bob Smith, 2001.

... some sort of
zombie afterlife.

M Beuys isn't a hot name anymore.

B That's because he's dead.

M His things only seemed to work if he was there in person, being a Shaman. Or if you're a head of a kunsthalle somewhere who has to dust them every day and you want there to be a point to that. So in your Beuys-coyote work you're tapping into this dead phenomenon and giving it a zombie power. Such an afterlife is at least something. It's trivial compared to Beuys's towering greatness. On the other hand, if that greatness isn't real then, well, trivial is a notch above zero.

B He's a Don Quixote windmill to attack.

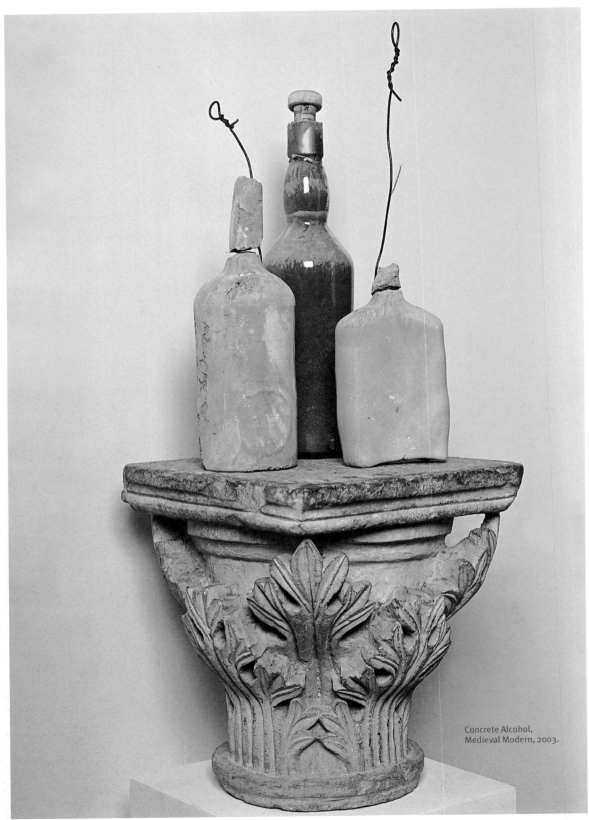

Concrete Alcohol,
Medieval Modern, 2003.

Upside Down Is The
Right Way Up, 2002.

Leeds Is The New
Hull, 2003.

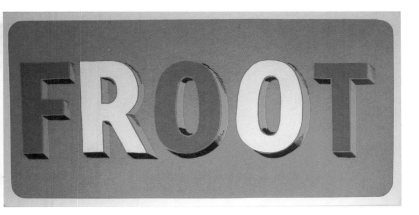

Froot, 1999.

∨ Pashon, 1999.

PASHON

Floresent, 1999. >

FLORESENT

Soop, 1999.

Le Cock, Le Cunt,
The Chop and a Pint
Building a flash newcastle one day
A minstral past the kings way
"Oj King, I'll grant you a wish
The Gift of Morter" if you grant me the
"Hand of your daughter. The King Smiled and Said
"Oh Okay". Parking his car the Stoooopid King
Thought "Wha Hey"
I'll finish that Castle today
Now that everything turns to concrete.
Jrst at the Stamp of my Feet
When everything is finally complete
I must find my beautiful Queen for a Lay.
The King Collapsed on his throne
Does everything I ~~touch~~ touch have to turn to Sto
The Queen thought Qvick
Dont Scratch your dick
To Late OK wae The Uncommon
King of Leytonstone

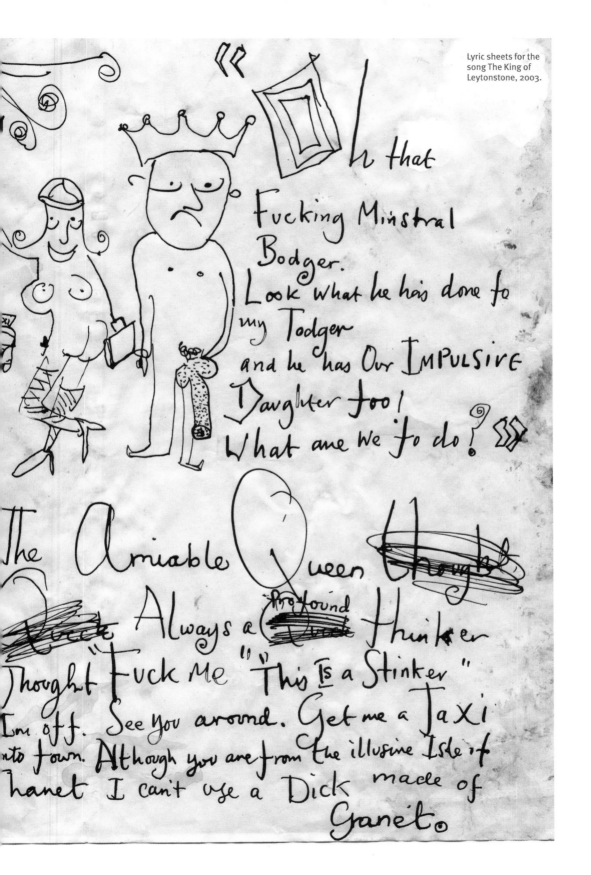

Lyric sheets for the song The King of Leytonstone, 2003.

Oh that Fucking Minstral Bodger.
Look what he has done to my Todger
and he has Our IMPULSIVE
Daughter too!
What are we to do?

The Amiable Queen Thought
Always a Profound Thinker
Thought "Fuck Me" "This Is a Stinker"
Im off. See you around. Get me a Taxi
into town. Although you are from the illusive Isle of
Thanet I can't use a Dick made of
Granet.

Nuffin Is Reel, 2002.

All German
artists have
sausages –
Beuys,
Dieter Roth,
Franz West,
although he
is Austrian...

M Is that the only dimension to it? Part of you loves the Beuys idea, I always imagined – presumably another part is, I don't know, suspicious of the institutionalisation of the relics maybe?

B I have spent a lot of time attacking Beuys utterly pointlessly, and it's because I am really impressed by him, yes. But you're right, he is dead in the water. But he's still fun because he's got lots of artistic mythology, which is another big theme of mine. He's got daft things, like his funny hat and his wax, and his absurd coat and sausages. All German artists have sausages – Beuys, Dieter Roth, Franz West, although he is Austrian. Anyway, Beuys has these items that you can put on and you can become Beuys very quickly. That's fun.

M Are we still on the first chapter? I think we should get on to Chapter Two.

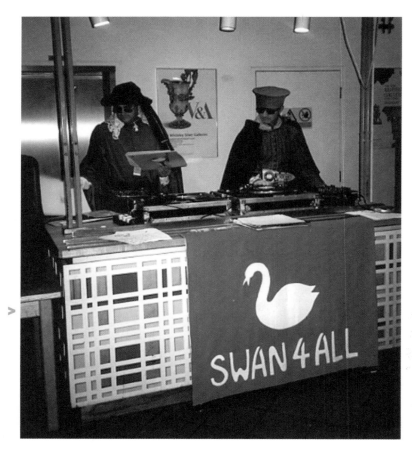

Swan 4 All, David Burrows and Bob Smith sell swan burgers and DJ bird song and Gregorian chanting at the Victoria and Albert Museum, 1971.

New Language
Reward Badge, 2000. >

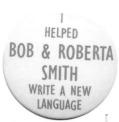

New Language
Questionaire Card,
2000. v

Help Bob and Roberta Smith write a New Language
for the New Millennium.

My New Word is ...DUUNJAI.. (doonji)........

please write the definition here...A MILD.............
...swear word - in exclamation......

Statements Art31 Basel - Anthony Wilkinson Gallery, London

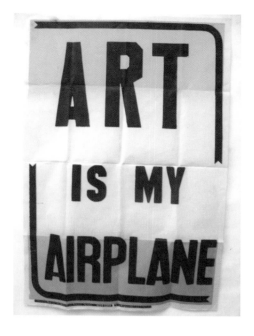

∧ Art Is My Airplane,
2004.

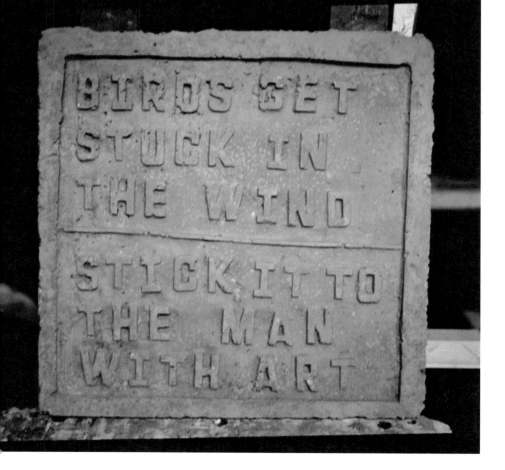

◁ Birds Get Stuck In
The Wind/Stick It To
The Man With Art,
2004.

LEFT
IS THE
NEW
RIGHT

STUFFED
WHAT?
ME?
OH YES

THE
ART
SCHOOL
OF
THE
REPUBLIC

NO
AIRPORT
AT
CLIFFE

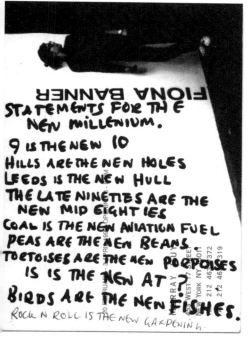

Peanis, 1999.

CAVES
ARE THE
NEW
MOUNTAINS

FIONA BANNER
STATEMENTS FOR THE
NEW MILLENIUM.

9 IS THE NEW 10
HILLS ARE THE NEW HOLES
LEEDS IS THE NEW HULL
THE LATE NINETIES ARE THE
NEW MID EIGHTIES
COAL IS THE NEW AVIATION FUEL
PEAS ARE THE NEW BEANS
TORTOISES ARE THE NEW PORPOISES
IS IS THE NEW AT?
BIRDS ARE THE NEW FISHES.
ROCK N ROLL IS THE NEW GARDENING.

HERE ARE SOME
NEW WORDS.

ARTISANAL.
FILOSOFY

Promt cards for
reading at the ICA
curated by Matthew
Higgs, 1999.

EUROPE
IS THE
NEW
INDIA.

Screen prints
commissioned for
the Royal College of
Art, 2003.

61

LADS HODGER INT TEN HOUSE. NIDS GOT HIS MAGSOWT. ONE LADS BARNGITTER SWELZ UP. HIZ MAM TAKES IM TO OSPITAL. SERJUN STICKS STRAW DOWNT BARNGITTER 'N' GITS YELLA STUFF OWT. TEACH THEE TO HODGER INTEN HOUSE. YA GOT TINFECTION FROMT TENS.'

B I'll just explain quickly The King of Leytonstone – this is another work. The King has an awful affliction. He has a Midas touch. Only, instead of gold everything turns to concrete. The Queen says, "Don't scratch your dick", but he does and then she moves from Thanet because she can't use a dick made of granite.

M And this is the form of the work – a poem?

B Yeah, well it's also a song on a CD and a show at a gallery called Medieval Modern. I don't care about the form of work.

Everything turns to concrete.

The King of Leytonstone addresses the people of Thanet, 1940. >

 Lads Hodger, 2002.

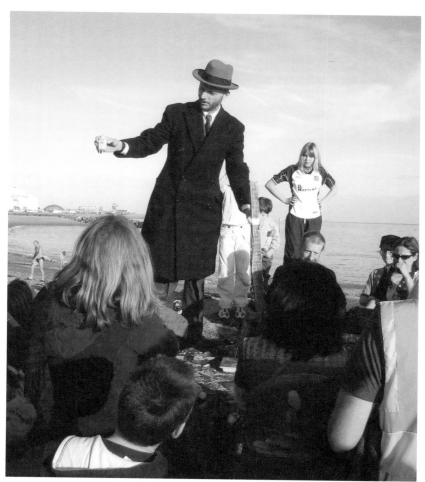

O D E T

P O I S

G L A D E

A N T I

A E S T H E

2

O O THE

N E ED OF

SOCIAL A L

S

T IC

**thinking about creativity
through destruction**

BEAT
'SONIC
YOUTH'
THE DONKEY
$1 A GO

IS
RUBBISH

THURSTON
MOORE

The Poisoned Glade
Of Anti-social
Aesthetic,
installation view,
Bard College Gallery,
2004.

RALPH
NADE
LOOKS LIK
STICK INS

NOAM
CHOMSKY
TALKS
THROUGH
A HOLE
IN HIS
HAT

CAPTAIN BEEFHEART'S
MUSIC IS SHIT BUT
HAVE YOU SEEN HIS
PAINTINGS?

BEAT
'SONIC
YOUTH'
THE DONKEY
$1 A GO

THURSTON
MOORE

Sonic Youth The
Donkey, The
Poisoned Glade Of
Anti-social Aesthetic.

thinking about creativity through destruction

B So, here we are in the Poison Glade Of Anti-social Aesthetics. And this here is Sonic Youth The Donkey, you could beat it for a dollar a go because Thurston Moore is crap.

M You find ways to three-dimensionalise ideas...?

B The King of Leytonstone is just one song, and then it's made into a theatricalisation. And, actually, as my installations go on, I'm trying to get back to making them more theatrical. I want to get away from making pieces.

M Right, more environmental.

B I think theatrical is a good word because that's something you can't do in the art world. People hate theatrical.

M They don't really, but they know they must dutifully repeat the received idea that the theatrical is excessive. They suspect it's something to do with received ideas of other negatives, such as the decorative or the entertaining.

B Yeah, well entertaining, that's another thing I think about a lot.

M The danger is that entertainment is trivial. It's not knowledge. Knowledge is important, because with it you can get empowered and have a revolution. Entertainment keeps the status quo going, because everyone's just sitting around laughing – they don't realise they've got to overthrow an oppressive system. There's very little in Adorno that's entertaining, unless you're already quite educated and in the habit of reading a lot at that highbrow level. So, from this a picture forms in the contemporary art-person's mind, of a thoughtful and wise power guru occupying an intellectual power zone. Good. And then on the other hand – Bad – a world of lies. Maybe CNN or the CIA or McDonalds or Brian Sewell or the National Gallery, where you don't care about thoughtfulness and being radical, and all you want to do instead is be entertained.

There's very little in Adorno that's entertaining...

Ode to the Poigened glade of anti-Social Aesthetic

Verse

PIANO CHORDS

4/4

F x 2 bars

E x 1 bar

D minor ½ bar

Noam Chomsky talks through a hole in his hat

- Ralph Nader looks like a stich insect.

Micheal Moore is Fat.

- Robert Smithson is a Snake Oil Seller

- Bill Murry Cant Act

Tony Ourslerly Just does the same thing
over and over

- Bruce Nauman is overwieght and his
work is Stupid.

Chorus

F x 4 bar } x 2.
G x 4 bars }

Beat Sonic Youth the Donkey !!!

coz

Thurston Moore is crap !!

Last Chorus

And I hope I dont End up like
Lawence Wiener

- Bob + Roberta Smith

Ode To The Poisoned Glade Of Anti-
social Aesthetic, lyric sheet, 2004.

B Part of my thinking comes from Baudelaire. With him it is just a pure strange melancholy, but funny kind of entertainment. There's something very dark going on underneath.

M Is the darkness disillusionment?

B Yeah, maybe. I don't know if that's totally the case with me, particularly, but I do know entertainment with me is a surface thing. If you're completely immersed in the entertaining aspect of art, then I think what you just said is true. But my way of dealing with that is it's a way of getting people through ideas, sort of swiftly, and, also, it's a way of saying some quite profound things. It allows the viewer to put two and seven together and come up with 742. Comedy is always about tragedy. Anyway… Art is a branch of the entertainment industry. Artists try to dress in Adorno cloaks to shun crowd pleasing, but lots of art is simply corporate wallpaper. You could call me an old Marxist, but certainly the Art Market is just super duper rich people expressing themselves. Anyway, let's move on to some other works. Look at this one. It's a thing I did for a cancer charity.

M "Well, we've all got to go one day" written on a candle…

B Sad, isn't it? They gave all these candles to artists like Mona Hatoum who stuck needles in hers, and it sold for £1,000. Mine was remaindered at the auction. It said, "My aunt left us nothing, she left all her money to cancer research and the cats home and she didn't even die of cancer or have a cat." It's not particularly deep, but it's obvious what the darkness of it is with that sort of humour. I think the cancer charity has still got those candles. All my efforts for charity have been a bit like that. This is a horrible piece of work actually this one – this was when I went round galleries in New York having a pee in their front windows.

M It has the same look as that photo of yours from years ago where it's snowing in New York and you're looking in the window of the ritzy gallery feeling left out.

B Well, I peed in about ten galleries' windows, including Mary Boone.

M And is this from the same time?

B Yeah.

M Tell me about your work called The Public Beating. It's something the public can buy, isn't it?

B They buy protection of increasing effectiveness with increasing cost. So, then I beat the public, which is a straight lift from a Baudelaire idea – beating the poor. He beats up a poor man who asks for money, and then the poor man beats him up. Look at this. This is my Art Amnesty, where I gave cards to people and they had to sign them to promise to "never make art again". And then I gave them a badge saying, "I'm no longer an artist", and then we collected up all their work and put it in a skip.

M Did they make the skip themselves?

I beat the public...

A PUBLIC BEATING

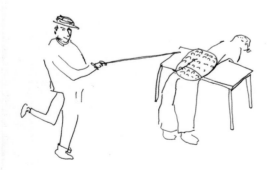

⟨ A Public Beating, drawing for unrealised performance, 2003.

The public can buy protection of increasing effectiveness for increasing cost.

Poster for Kunstzene ⟩
London, 1997.

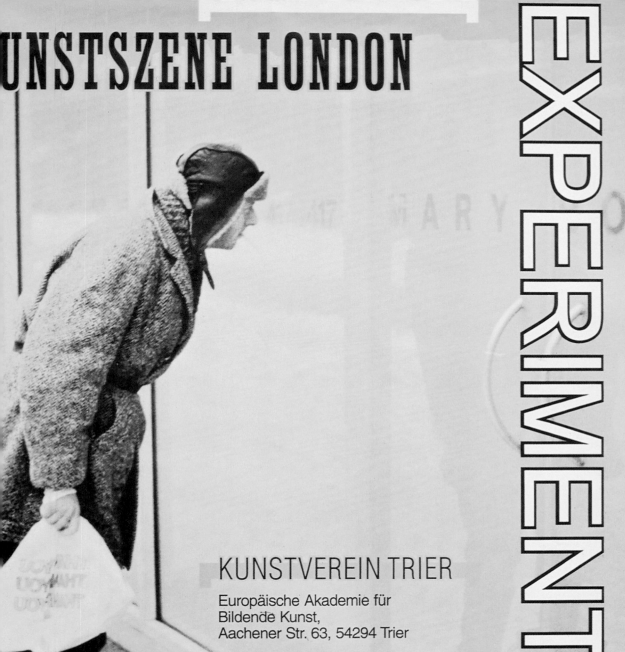

UNSTSZENE LONDON

EXPERIMENT[GB]

KUNSTVEREIN TRIER

Europäische Akademie für
Bildende Kunst,
Aachener Str. 63, 54294 Trier

Vom 1. bis 23. Februar 1997
Di - Fr 12 - 18 Uhr, Sa - So 11 - 17 Uhr

KUBUS Hannover

Theodor-Lessing-Platz 2
30159 Hannover

Veranstalter: Kulturamt der
Landeshauptstadt Hannover

Vom 23. März bis 27. April 1997
Di - Fr 11 - 18 Uhr, Sa - So 11 - 16 Uhr

Throw Art Away,
Economist Plaza,
London, 2003.

'Artists – down you easels'

AN EXHIBITOR at the Deptford X festival has said most artists should give up and "get proper jobs" in a savage attack on "bad art".

Bob Smith, 39, said: "We need to try to cut down on artists in Deptford, especially all those well-meaning ones who should be getting jobs and settling down.

"They are all kidding themselves that what they are doing is incredibly important when they would be far happier if they just stopped. They all have to believe in what they are producing and it has to seem to them it is the most important thing in the world, when obviously it's not at all."

As part of the festival, Mr Smith, from east London, and his sister Roberta are calling on artists to "decommission their easels" and renounce their art. He said: "My idea is to get them to give up their materials, their tins of paint or video cameras or marble chisels or whatever."

And Mr Smith, a fine art tutor at Goldsmiths College, said the fault with all this "bad art" is too many ideas.

By MIKE PFLANZ

He said: "One of the main qualities of all this bad art is it is loaded with inane, supposedly profound moments. They're the ones that get me the most."

But not everyone is impressed with Mr Smith's stance on "bad art". Catford artist Teffany Osborne reacted angrily to what she calls Mr Smith's "gimmick".

Ms Osborne has an exhibition in Kensington's Cromwell Hospital and has had work shown in the Victoria and Albert Museum and at the Royal Academy.

She said: "What he's saying is very negative and could be quite disruptive. Who is judging what is good art and what is bad art. There are two sides to a piece of art, the creative part and the technical part. Sometimes it takes time for the technique to improve, but it does over time."

● What do you think? Is Mr Smith going too far? Write to: *The Mercury*, 116 Deptford High Street, London SE8 4NX.

● Deptford X festival preview, p27

Bob Smith wants 'b...

NO L
AN

> Press clipping from the Deptford Mercury, The Art Amnesty, 19 June 2002.

> Prize Badge for artists who pledge to give up art. Art Amnesty, Deptford X London and Peirogi New York, 2002.

B Yes. They got all their work from their studios. And then we put it in a decommissioning centre, modeled on the IRA Peace Process. They could bring in their easels and paints, and they could also do their last drawing. You're looking at the text for it now.

M I'm sure many people reading this text might have memories from the 60s and 70s right up to recently, where people give up art as a gesture to help stop the Vietnam War or some other cause.

B Like Metzger's art strike...

M ... up to Stuart Home going on his art strike in the 1990s. Maybe it was done more recently too, I don't know. And what one senses is, yes, it's an action that comes from the 60s and 70s, and, yes, it's socially oriented and it's communitarian, and it's got an idea, and also there's a tiny little droplet of self-importance. And, in a way, you're summoning up the whole vibe. But the one thing you're homing in on in a rather sadistic way, with almost surgical accuracy, is the self-importance. But when I look at these photos of The Amnesty I don't feel I know exactly what the target is.

I PROMISE
NEVER
TO MAKE ART AGAIN

..
(you sign here)

decommissioned'
son Gallery, London/0054/M

Pledge Card,
Amnesty for "bad
art", Deptford X,
2002.

>

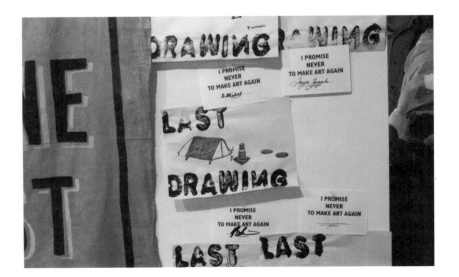

B I did The Amnesty in London, but I also did it in New York, in an artists-run
space in Williamsburg, which really thrives on all the good will of all the
artists there. The whole thing about Peirogi 2000 – which is the name of the
Williamsburg space – is that it's all run on good will, on good-natured
people, on artists, all helping each other out. And the person in charge has
loads of flat files and plan chests there, so he represents about 500 artists.
At the opening, people took The Amnesty in the right or wrong spirit, but one
bloke got really mad with me and he said "You British bastard, the artistic
community has been through so much after 9/11, the last thing we need is
you coming here with your misplaced Monty Python humour", and he
started pushing me around.

Decommissioning Centre, artists are invited to turn in their art materials and take a **V**
vow not to make art again, Deptford X, 2002.

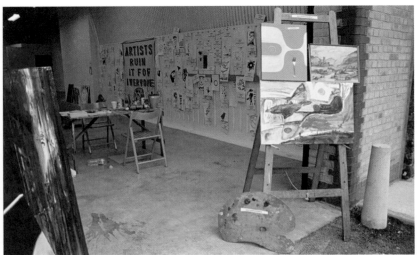

Al-Qaeda was targeting artists...

ARTISTS RUIN IT FOR EVERYONE

Watteau Is A Shyster,
2001.

Push Artists Into The
Sea, project realised
in Folkestone for
Navigating History,
2004.

M Like Al Qaeda was targeting artists!

B Yeah, he started pushing me around. He didn't actually thump me in the
head, but he pushed me up against a wall at the opening. He had a red
checkered shirt on....

M You touched a nerve. That's good isn't it?

B Well, I mean you feel embarrassed when you're confronted by the end result
of some of these things, and sometimes you think why am I such a chump to
have done that, to have annoyed him in that way? But in another way it's
good and it doesn't really matter. Afterwards I had to play a gig. I was
distracted and it was disastrous, the gig went really badly.

M Well, maybe good isn't the word. But your story does highlight the nature of
the consciousness raising that you're doing, which is not quite as it may
have seemed when we were speaking earlier. When you're talking about
modes of conceptual art there might be a more entertaining mode or more
solemn mode, but in the end, you know, you're leading towards
enlightenment of some kind. But, actually, if you really look at what kind of
enlightenment you're looking at, it's a sort of wanting to partly empower
people and give them the inspiration to think for themselves and bring out
creativity in everybody...

He had a red checkered shirt on...

Botticelli sucks, ▼
2002.

B ... yeah, which is a genuine thing.

M Absolutely. But you're also saying it turns out that once you do that, don't expect it to be all cuddles and hugs. Once you do wake up a bit, don't expect life to be all friendly. It might mean you'll have to drop some of your illusions. A bit like the therapy moral at the conclusion of the movie *Ordinary People*. And also, of course, a bit like reality, even if it has been covered in a movie. And what this checkered-shirt Williamsburg guy didn't like is that he was having an illusion punctured in a difficult to avoid way.

B And, also, you've got to go in there and think, with all of my work really – well, a big chunk of it – you've got to go in there thinking, "He doesn't mean what he's saying!" Whereas, with art normally, you're meant to swallow the shit whole.

M Have some sincerity, dude!

B A lot of my statements are totally disingenuous. That's something I employ, that disingenuousness – trying to be straight faced. Say something to somebody and they either whack you in the face or...

M ... or they get it?

B Yeah, but that's a sort of dangerous territory. Now we're looking at the Throw Art Away prints that you could buy for a dollar, and then there was a bin in the corner of the gallery where you could put them.

M That's a lovely image actually. The typefaces are nice, and the colour and the black and white, and the lovely wrinkliness that happens to the paper when you print on it...

B All those things are typographic. They're to do with getting something across in a concise way. Actually, I relish that level of the visual, whereas I feel uncomfortable about the 'aesthetic' as such. This other level of ordinary aesthetics seems a worthy one, even righteous. I know that's just stupid really, but...

⋀ William Blake Is A
Low Life, 2002.

Throw Art Away >
prints, installation
view, Peirogi Gallery,
2002.

being selfish

Cover plate for A to Z ∧
Book made in India,
published by
Immprint, 2000.

M Aesthetics cut down to size seems good, but the aesthetic level as a kind of aim or principle in itself – you're not really sure what you're supposed to be engaging with?

B It's because I sense pipe-smoke and pondering...

M The typography in Throw Art Away is your own design, isn't it?

B Yeah, I did it on the computer. Now, you can just type in anything and it comes out like that.

M Everything you say you believe in is doubtful in these works, and yet your whole schtick as an artist is that you have this belief in old fashioned virtues, like communitarianism, and society, and not being selfish...

B I'm not sure about communitarian.

◄ Who Saw My Last
Show? 1993.

Humiliate Video, 1993.

M Having some sense of the community, as opposed to the Thatcher era, of thinking that greed is good.

B Yeah, I know what communitarianism is Matt. But I like to attack liberals. John Lennon was 'good' until he started telling people how to live their lives. On the other hand John Heartfield is my favourite artist.

Promt cards for Humiliate Video, written on the back of private view cards, 2007.

I SENT SOME SLIDES TO THE PACE GALLERY IN NEW YORK. I GOT THEM BACK SIX MONTHS LATER WITH A NOTE ATTACHED... SEEN IT BEFORE PAL.

STUART MORGAN ONCE WROTE BOB SMITH'S WORK IS 'FUNKY'. LATER I THANKED HIM. HE SAID WHY? WELL, I SAID I THOUGHT YOU MEANT IT WAS 'HIP', 'GROOVY', 'NOW', 'TODAY', 'FUNKY'. HE SAID NO BOB I MEANT IT IN THE AMERICAN SENCE I.E. WHEN THEY SAY MILK IS OFF THEY SAY IT IS FUNKY YOUR WORK STINKS!

...LD AND COME BY AND VISIT THE GALLERY AND TALK ABOUT THE WORK. SO I WENT IN. MR. FELDMAN SAID IT WAS IMPORTANT MIKEY CURRANTY WORK AND I SHOULD SHOW HIM SOME NEW PAINTINGS MORE IN 18 MONTHS TIME. I SAID 18 MONTHS IS NOW THIS TIME!

Chuck Close Is Crap,
original plaster cast,
2003.

... if you top yourself Bob, I'll introduce you to my sister.

ok

L B E L L I N D 3

the big figures in art and politics
should we love them or hate them?

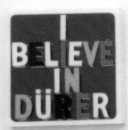

I Believe In Dürer,
installation view,
Kunsthalle,
Nurnberg, 2000.

 the big figures in art and politics, should we love them or hate them?

M When you have a beer mat that says "I Believe In Dürer" we don't think that you do – we think you could just as well say Caravaggio or Shonibare.

B Well, Dürer is good because he was the first one to get art out there, with the printing press and selling prints at fairs. So, that is genuine.

M There is something he does that you're actually impressed by?

B Oh yeah, he's a fantastic draughtsman.

M So, a lot of these 'I believe ins', there actually is a bit of belief in them?

... get art out there....

GREAT ARTISTS
Wee Wee artists
Lazy artists
Genius artists
USELESS ARTISTS
Easy Going artists
UPTIGHT Artist
POO POO Artist
OK ARTist
DEAD ARTISTS

◄ Some Different Kinds Of Artists, free print given away at the Basel Art Fair, an initiative by the Migros Museum, 1998.

▲ Coaster developed to
promote I Believe in
Dürer, Kunsthalle,
Nurnberg, 2000.

... it's too Radio Four....

Hero's Of Humanism ∨
Bicycle Pilgrimage,
press cutting,
Beacon Project,
2004.

B Certainly. Orwell is a big figure for me. Orwell is the constructor of inventive political thinking, and he comes up with a really good structure, which is like *The Prisoner* really. The idea of individuals working within systems and how you operate with that. And he also did fantastic things, like acting the role of a tramp. He must have been a very unconvincing tramp, walking around, having been to Eton.

M I think another notable thing with him is that he has a great intellectual capacity, but it leads him to despise and be suspicious of intellectuals – he sees them as a real source of problems and difficulties within the community.

B Maybe. It's too Radio Four to get caught up on him. I think that idea you mentioned about that little drop of self-importance, which – my God, making a book of all this stuff is completely an act of self-importance. But it's one of the key things that entertains me – this realisation that all artists are astronauts flying spaceships fuelled by self-importance.

> ... all artists are astronauts flying spaceships fuelled by self-importance.

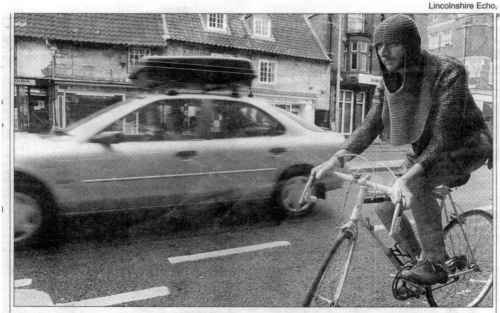

Lincolnshire Echo,

A KNIGHT'S TALE: Artist Bob Smith (41) has embarked on a bicycle pilgrimage to help launch the Beacon Art Project – which is taking place across the county over the next four weeks.

The bike ride began at St Mary's Guildhall, in Lincoln's High Street, and finished up at Temple Bruer, near Sleaford, yesterday.

Mr Smith said the journey was a tribute to three of his biggest heroes.

"The bike ride was a humanist pilgrimage to Temple Bruer," he said.

"There is a beautiful chapel there with some old graffiti in it.

"Inside, I have made a shrine to three of my heroes – Darwin, Orwell and Joe Strummer.

"They are my three big heroes of humanist thinking.

"I have placed a concrete slab with the phrase 'I believe in Darwin, Orwell and Joe Strummer' on it, and people can visit it over the coming weeks."

The Beacon Art Project is an innovative visual arts project curated by John Plowman.

The project highlights the way in which different artists have responded to the sense of history of various sites across the county. A coach will leave the city's High Street at 10am and 2pm on Fridays, Saturdays and Sundays until October 9, taking in such historical local sites as the Dunston Pillar and the Reading Room and Chapel at Wellingore.

☎ For more information contact (01522) 811809.

Picture: Chris Vaughan.

Picture reference: 4-6309-15.

I Believe In George
Orwell, 2004.

Four women dressed as Beuys in the Collective Gallery, 2003.

BEFORE THE WAR
JOSEPH BEUYS WAS
A STUKA PILOT

WHO KNOWS HOW MANY
INOCENT CHILDREN AND
WOMEN HE MURDERD
BEFORE HE WAS SHOT DOWN
ON THE RUSSIAN FRONT.
WOMEN ONLY DRESS AS BEUYS
AND SEARCH THE GALLERY
FOR JEWS GYPSIES AND HOMOSEXUALS

Joseph Beuys Was A
Stuka Pilot, 2004.

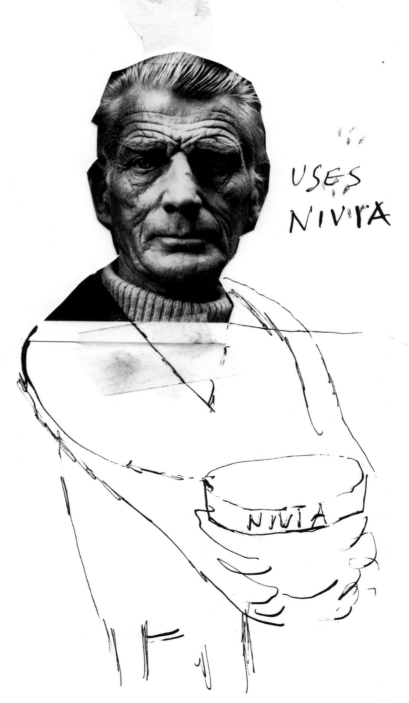

FUCK ING BECKETT

USES
NIVIA

NIVIA

Fucking Beckett Uses Nivia, 2002.

James Joyce's Skin, 2003.

... here is your ID card.

M Presumably ego has got to supply a lot of the drive for creative people when you get beyond the level of mere childish play. It keeps them fighting to be more ambitious and to achieve more intensity.

B You see, that's all really fantastic, and it would be terrible if people felt artists couldn't do that. What I'm trying to get at are the weird distortions of artists' thinking, or more recently politicians' thinking. If you took a young left wing politician, he'd be a hippy trippy kind of person thinking utopian thoughts, thinking, "Wouldn't it be great if we could live like this or that?" But then, later on, they become New Labour, they come in to government and they think, "You will live like this and that and here is your ID card." Orwell was good at highlighting this with 'ingsoc', the Labour party as it gets distorted after decades of power.

M You like Burroughs as well, don't you? Why him?

B Well, all sorts of things. One of the things is the intonation on the Call Me Burroughs record, where he reads his poetry in a deadpan style – snippets of *Naked Lunch*, saying the most outrageous things. But this is done with incredible tone and pace, which is really beautiful. Another thing I like is the post-Surrealist cut-and-paste process of putting texts together. A composed graphic process, a stream of consciousness kind of thing, cut-up and stuck back together. It comes out of the 'exquisite corpse' idea. It's how I come up with lots of the texts, although I don't leave the Sellotape on like he did.

I don't leave the Sellotape on...

ELVIS DID NOT ENJOY HIS TIME IN GERMANY. HE TRIED TO ESCAPE ONCE. AS HE BOARDED A BUS IN TOWN A GUARD THOUGHT HE RECOGNISED HIM. GOOD LUCK 'KING' HE SAID. THANK YOU ELVIS REPLIED. THE GUARD THEN ARRESTED HIM.

◄ Elvis Text, 1997.

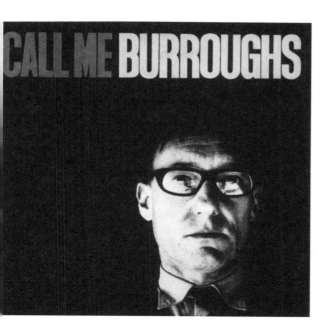

Call Me Burroughs,
LP cover, 1965

▽ Brueghel Text, 1997.

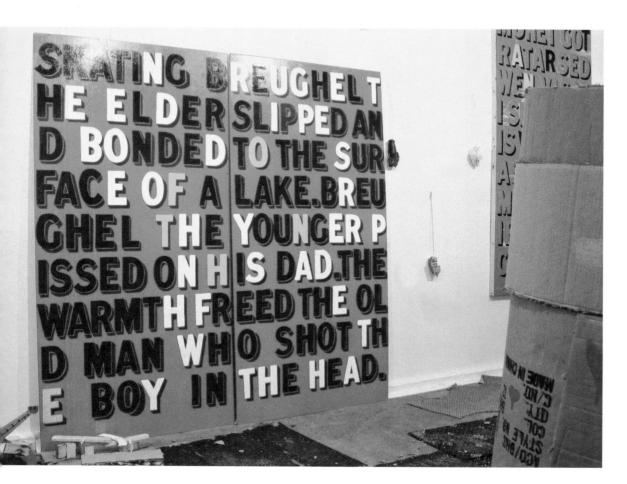

I Believe In The
Clash, 1998.

I Believe In Gustav Metzgar, 2003.

FRANZ WEST HAS EXPLODED

Franz West Has Exploded, 2004.

... lazy and stupid.

M But you admire his trusting in random juxtapositions.

B Yeah, the serendipity of it. But in my work I hide all that, and actually he hides all the putting together of it in this incredible iron clad voice.

M Yes, controlled anarchy is your thing. Part of it is economy of means, which is impressive. Another thing is the control that you have over something, which by its nature seems should be out of control – silly burbling of trivia just in order to be annoying. I suppose that's the link with Burroughs. Out of control but in control. In his case those images of disgust – amplified exotic disgust – which he delivers in that rather T S Eliot tone – the uptight, clipped, repressed banker type of voice. And the contrast gives the material a lot of its impact. What about your bad spelling? You can't spell. You utilise it. You don't carefully invent funny bad spellings.

B I'm not a great speller, no, but actually I failed all the dyslexia tests at primary school. The examiner said I was just lazy and stupid.

Teddy Kennedy Text, **>**
1996.

I Believe In Martin **>**
Luther King And
Other Heros Of
Humanism, 2003.

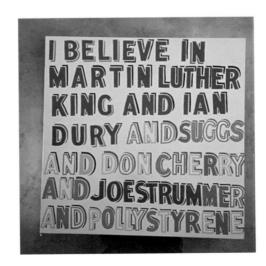

TEDDY KENNEDY VISITED HAROLD WILSON. WILSON REMARKED IT WAS TERRIBLE WHAT THEY DID TO YOU IN DALLAS TED SAID I THINK YOU ARE CONFUSING ME WITH MY BROTHER.

Frank Zappa's Rubbish, 2004.

Baudelaire is a flat headed cockroach. ①

Voltaire is a subhuman conceptual HORSEWIPE.

Richard Wagner is a lowlife Pig fucker. ②

Edgar Allan Poe a bolloch brained Shitstain.

Balzac is a flatheaded deadhawk CRETIN ⑩

Ludwig Van Beethoven IS A pigwitted retard. ③

Hector Berlioz Berlioz ignant Gobshite

Mussolini is a right Charlie ⑧
NELSON IS A FOOL.

The Railway Children is Filthy Racist Shit. ⑥
ZADIE SMITH CRAP

THE WIND IN THE W...
KENNETH GRAHAM IS A DEGENERATE

Andrew Motion is a savage.

Thomas Hardy is A FLEA BAG.

Yoya is a divy tossbag.

Victor Hugo is a DIMWITTED LEACH LEECH

St John Betjeman is a Abortion DOGS DICK

Joey Ramone is a Maggot.

Iggy Pop is a twat head.

Dee Generate bolloch brain

Shakespeare Dave Vanian is a Mindless toerag idiot.

Nigella Lawson Cant Cook
ZADIE SMITH CANT READ

Kurt Cobain is a bad dusty ⑤

Iris Murdoch is a Ginge minged Rusty Bucket

NAPOLEON IS A TOOL
NELSON WAS A FOOL
MUSSOLINI IS A TOOL TO YELLOW

⑨ Freda Kalos has one big Furry eybrow AND here Eyes are too close together.

AND HER EYES ARE TOO CLOSE TOGETHER

IMP
THE

4

art does you good?

I WANNA DO

List put up at Farnham Foundation Course by Bob Smith to find out students' preferences for the final term, 1996.

LIV STOKKAN

JENNY SIMONDS

ALAN LIDDIARD

PIERS SECUNDA

NIKI

JOAN

ALEX

ELEA

Car. The public were invited to make cardboard cars to place on a model motorway in order to create a traffic jam that got worse the longer the exhibition went on, Middlesbrough Art Centre, 1996.

FINE ART

ALISTAIR CARTWRIGHT

Waiting. The public were invited to make cardboard cars to place on a model motorway in order to create a traffic jam that got worse the longer the exhibition went on, Lotta Hammer Gallery, 2000.

 art does you good?

M Have you got any works to show me that are about doing good?

B Yeah, here's one. This is where I talked about potatoes with gallery-goers in Barcelona. I was collecting all their recipes and talking about the social significance of the potato. The potato is sort of a cultural icon for them. They believe Columbus brought it back from the New World – the French didn't know what to do with it, but the Spanish realised it was fantastic. There was this great social history via the potato. So, I wrote all their ideas down in this book and then at the end of the show I just threw the book in the bin.

M Having given them a sense of national pride in the potato you just trashed it?

B Which relates to Antonioni. In *Blow Up* the David Hemmings character goes to see the Yardbirds play, and Eric Clapton smashes up his guitar and throws it into the audience. The audience goes mad, all these young dudes are trying to get the guitar, but it's Hemmings who gets it. He really fights for it, and when he leaves the nightclub he just throws the guitar in a skip.

... great social history via the potato.

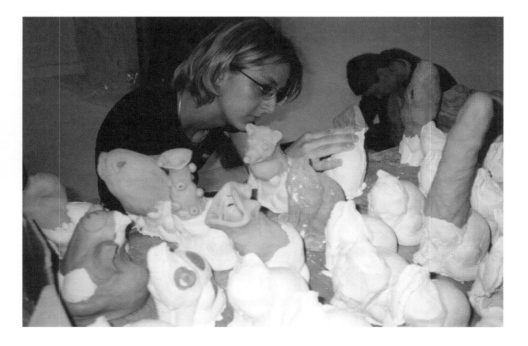

◄ Improve the Cat Carbone.to, Turin, 1998.

Lets Talk About Potatoes. Visitors are
invited to talk to Bob about potatoes,
Carbone.to, Turin, 2002.

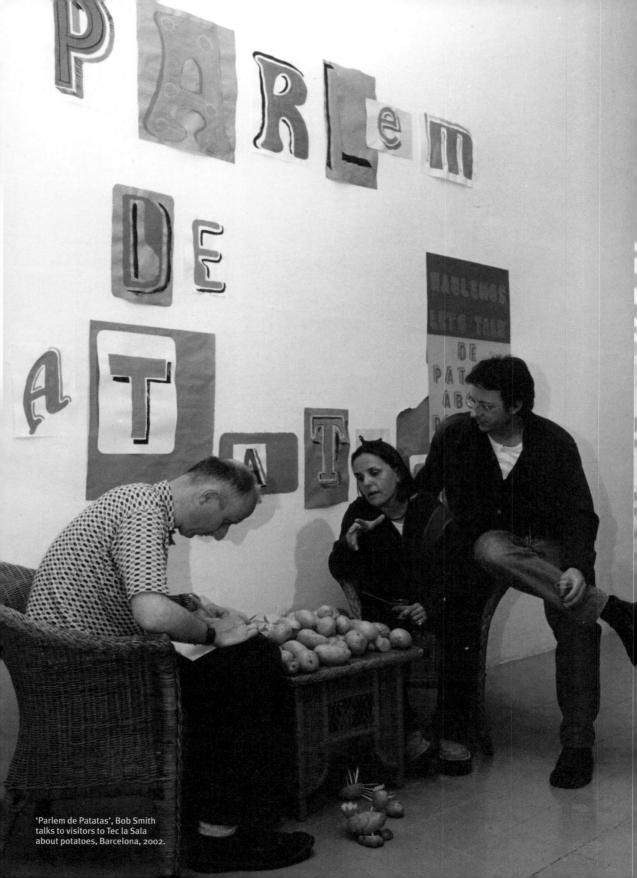

'Parlem de Patatas', Bob Smith talks to visitors to Tec la Sala about potatoes, Barcelona, 2002.

LORD ARCHER IS A POLITICAL PRISONER

Lord Archer Is A Political Prisoner, 2004.

I fucking hate the world

Bob Smith on Kamakura Beach, Japan, 1997. >

B There's something in that psychological journey that I really like. As an artist, you know it's all really important because you've got the important 'gallery' and the important 'show'. We act all important. I say to the audience, "You sit there and tell me all this stuff about potatoes." Then at the end I bin their thoughts. It's a slightly callous joke on the idea of do-gooding.

M The theme of realism runs all through your work – people think 'realism' in art is when you've got something that looks like something 'out there', but realism isn't the thing out there that's opposed to ideas. It's an idea in itself. It takes a lot of different forms. No one knows what's really out there.

B It's interesting you bring up realism because Antonioni is sort of an inheritor of Buñuel. Another thing I'm interested in are those 60s British social realist films, which were a complete construction of how working life was. It was well-meaning. It reminds me of this fantastic Derek and Clive sketch with Peter Cook taking the piss out of Jonny Rotten. He sings, "I fucking hate the world, I fucking hate you", and afterwards says, in a rather camp way, "Is that alright darling? Well OK, see you next Thursday." It's a bit like that – the truth of art.

M The truth of anything can be a bit deflating. In the context of what we've just been talking about, you go from a very heightened moment of idealism, the exhibition or the concert, say, but then everybody has to get the tube home, and on the tube you're gradually leveled down with all the other crap of existence.

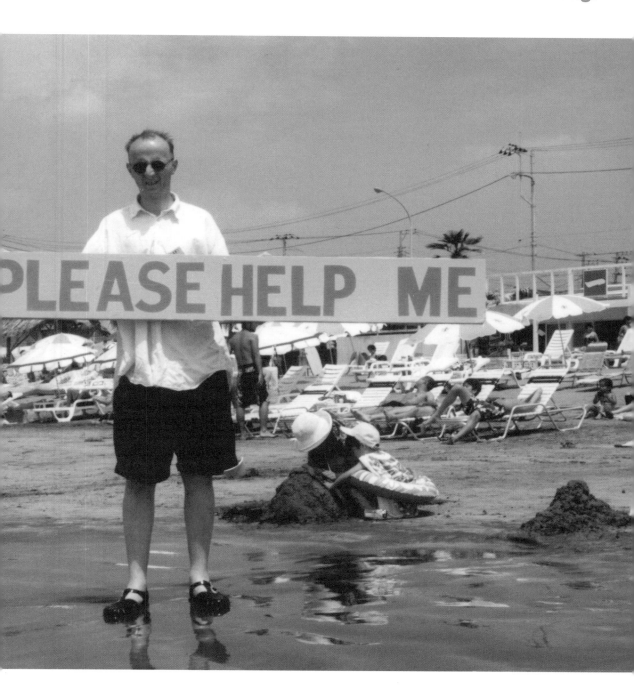

Car, Middlesborough Art Centre, 1996.

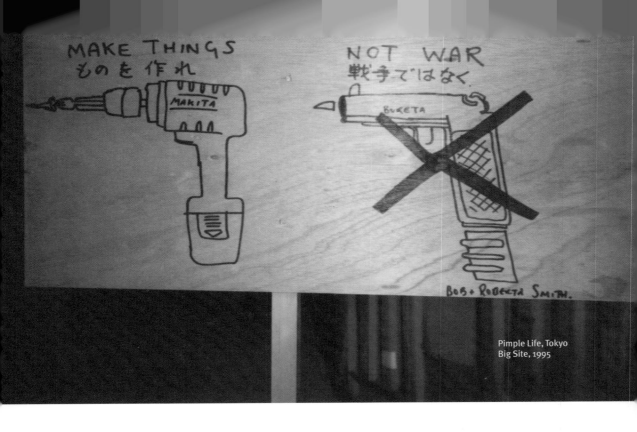

Pimple Life, Tokyo
Big Site, 1995

B I'm really interested in that 'on the way home' moment. That is an interesting
 thing about the Situationists and the Goldsmiths College thing, where lots
 of artists grabbed hold of Guy Debord and read all his stuff – he's the king of
 aphorisms – and they see he's always attacking the spectacle of this
 wonderful moment and saying we ought to be thinking about the 'walk
 home'. But actually the artists are all saying, "We want flashy art, groovy
 private views and success", which is all about the kinds of things Debord's
 attacking. The moment from *Blow Up* is somehow like this, and of the same
 era. There's something fascinating in that. It's a dualistic thing, because I
 love this idea that art could be like Mark Bolan – you've got your hot silver
 jacket on and you're stomping around being an artist. But then, also, I love
 this idea of Mark Bolan at home. The best thing would be to be Mark Bolan
 at home resting with your silver jacket on.

M Well, what we've been talking about is that there are structures of doing
 good socially and those structures themselves have their own fascination,
 but their failure also has a certain fascination. But in your art the doing good
 bit is always highlighted by distortion, by being obviously distorted.

**I'm really
interested in
that moment
'on the way
home'**

... we all want flashy art, groovy private views and success.

B Talking about doing good and not doing good is a diversion of mine, so as not to have to talk about how making art is actually liberating. I believe that. It's embarrassingly evangelical, but I do think art is really powerful and transcendent. For instance, after I came back from America, where I'd lived for a long time, and I didn't know anybody in London and I had to work in lots of shit jobs to keep going – I had unbelievably awful jobs, which I won't go into. But the thing that really kept me going was the idea that somehow I was an artist, which is a sort of transcendent thought. Although I wasn't actually making any art, or was making it in a limited way, it gave me an identity that meant I could exist in a world of ideas and thoughts.

▼ Paint it Orange, The public are invited to paint objects orange. Part of Don't Hate Sculpt, Chisenhale Gallery, 1997

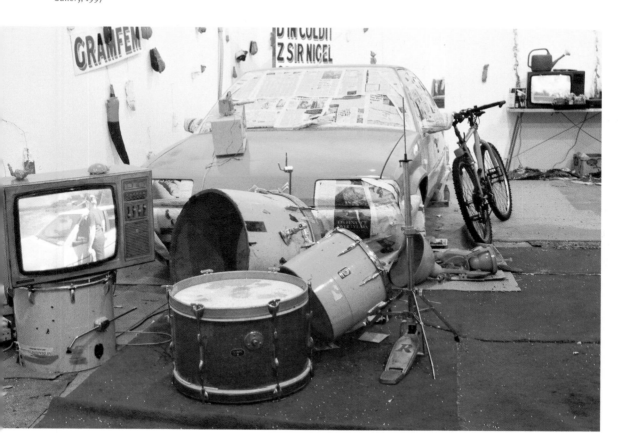

STRAW + HAGUE = ENOCH POWELL

RADIO ONE DJ CHRIS MOYLES IS NOT VERY GOOD

PUTIN IS A MONSTER

SHOP LOCALLY

BRING BACK NEWS AT TEN

I WOULD RATHER LOOK AT PHOTOCOPIES OF THE QUEENMOTHER'S ARSE

ANNA IS THE NEW NICK

GORD IS DEAD

10 YEARS OF BOMING AND STARVING IRAQ FOR WHAT?

G.8 EVIL

SAVE LONDONS BLACKBIRDS AND STARLINGS FOR AMAZIN MORNINGSONGS

VORREI CAMBIARE IL MONDO

INTERACTIVE ART IS A LIE

EAT BRITISH MEAT

QUEEN CAMILLA NOW!

ALL THEY DO IS NOTHING

FARMERS ARE THE NEW MINERS

GM FOOD PUTS HAIR ON YOUR CHEST

USE YOUR LOCAL LIBRARY

HANG PAEDO-PHILES

MORE RENBRANT

SAVE YSYOL GYMRAEG LLUNDAIN

GEORGE W. BUSH IS A BUFFOON

BACK BLAIR

LEAVE THINGS GREEN

Stop it write now, Installation View,
Tate Britain, 2000

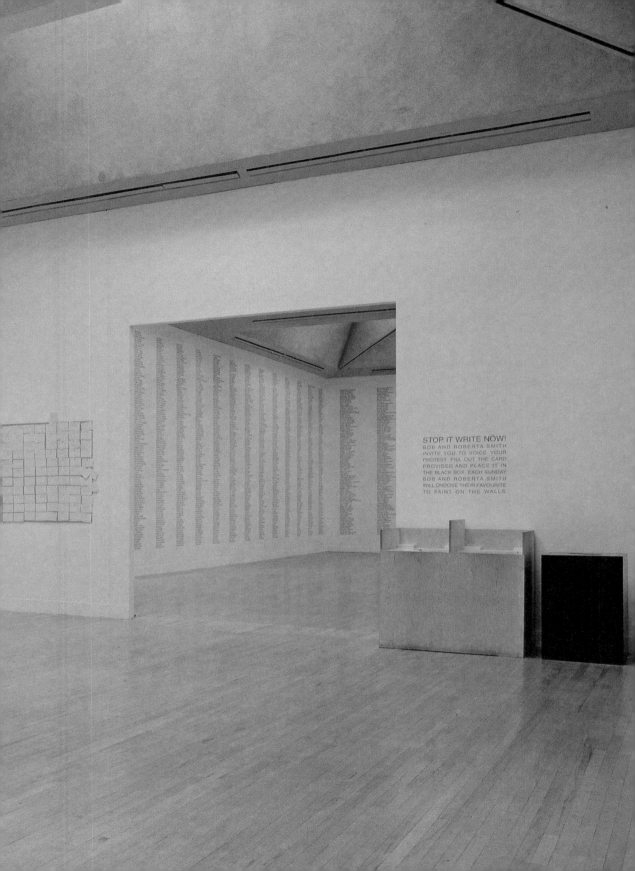

STOP IT WRITE NOW!
BOB AND ROBERTA SMITH
INVITE YOU TO VOICE YOUR
PROTEST. FILL OUT THE CARD
PROVIDED AND PLACE IT IN
THE BLACK BOX. EACH SUNDAY
BOB AND ROBERTA SMITH
WILL CHOOSE THEIR FAVOURITE
TO PAINT ON THE WALLS.

STRAW + HAGUE = ENOCH POWELL

RADIO ONE DJ CHRIS MOYLES IS NOT VERY GOOD

P
M S

I WOULD RA
LOOK AT PHOTO
OF TH
QUEENMOTHER'

10 YEARS OF BOMING AND STARVING IRAQ FOR WHAT?

G 8 = EVIL

SAVE LONDONS BLACKBIRDS AND STALINGS FOR AMAZING MORNINGSONGS

CA
IL
M

ALL THEY DO IS NOTHING

FARMERS ARE THE NEW MINERS

F
P
H
Y C

HANG PAEDO-PHILES

MORE RENBRANT

SAVE YSYOL GYMRAEG LLUNDAIN

SHOP LOCALLY

BRING BACK NEWS AT TEN

ANNA IS THE NEW NICK

BOND IS BLACK

INTERACTIVE ART IS A LIE

EAT BRITISH MEAT

QUEEN CAMILLA NOW!

USE YOUR LOCAL LIBRARY

GEORGE W. BUSH IS A BUFFOON

BACK BLAIR

BLA BLUR BLARB

LEAVE THINGS GREEN

SACK STRAW!

SAVE THE TIGER

BUT THE QUEENMOTHER'S GOT A GREAT ARSE

I AM STUPID BUT I UNDERSTAND

PITS NOT PIXELS

EAT SAVORY FOODS

YOU CAN'T BEAT A WOMAN

LET WOMEN RULE

POKEMON DIGEMON IS RUBISH

TONY BLARE HELP POOR PEOPLE

CAPITALISM GETS MY VOTE

BRITNEY
PISSES
ON
BILLIE

BRIAN
SEWELL
IS
FAB

ANIMALS
ARE NOT
FOR
FOOD

IF ANIMALS
ARE NOT FOOD
WHY ARE
THEY MADE OF
MEAT?

SIGNWRITING
IS NOT ART

VINYL
IS
DEAD

SAVE
C+A

SAVE
OUR
DOME

IN ZU
ARZ | BLAU

THERE IS
NO SUCH
THING AS AN
ENGLISH
SOCIALIST

ACTION
NOT
PROTEST

Brian's protest

MY DISTINGUISHED colleague Brian Sewell is unamused to find his name included in the Tate's *Intelligence* Exhibition.

Brian's review some weeks ago concluded: "Intelligence, an exhibition... pretending to survey the visual arts in Britain now, its boastful title utterly risible, is without doubt the silliest ever mounted by the Tate Gallery."

He is bemused, therefore, to find the slogan "Brian Sewell is fab" has been added to an exhibit called *Protest* by Bob and Roberta Smith. Members of the public are invited to submit legends for inclusion weekly, and more typical offerings have included *Sack Straw* and *All they do is Nothing*.

"I beg you not to give the work credibility by drawing attention to it," pleads Brian. "It is absolutely nugatory."

Tate exhibition shows abuse of Queen Mother

Emine Saner

OFFENSIVE remarks about the Queen Mother have gone on display at an exhibition at Tate Britain.

The work, Stop It Write Now! by Patrick Brill, is included in the Intelligence exhibition. Visitors are invited to write their thoughts, on any subject, on cards which are then posted in a ballot-style box. Every Sunday three or four are chosen by the artist to be painted on the wall, while the rest are pinned to a noticeboard.

While some of the comments, such as "I love S Club 7", are innocuous enough, many obscenities have been displayed, particularly about the royal family. One reads: "The Queen Mother at 100. Why are we celebrating? Set the people free." Another says: "Hang the Queen Mother."

One of the worst reads: "F*** the Queen Mother coz she got Princess Diana killed so she's gonna get sliced up. If you wanna help me my number's on the back. F*** the Queen by slicing her throt' [sic]." The mobile phone number written on the back of the card appears to be out of service.

One of the comments painted on the wall reads: "I would rather look at photocopies of the Queen Mother's arse."

The display has appalled many visitors. Mike Harrisson, a computer salesman from Calgary, Canada, came to London with his wife for the Queen Mother's birthday celebrations.

"It's disgusting that this is called art. I can't believe how disrespectful these people can be," he said.

"The Queen Mother is someone you should be proud of. She's a lovely old lady who has lived an amazing life, and it's outrageous that some punk is allowed to write offensive rubbish like this. The Tate should take it down. Nobody wants to see hateful threats, especially in an art gallery."

Brill, who uses the pseudonym Bob and Roberta Smith, says his exhibition challenges ideas of censorship. "I don't necessarily agree with the comments but it is a distortion not to include them," he said. "I do want the piece to be like a genuine toilet wall. I wouldn't want to live in a society where you can't make jokes about the Queen Mother's bottom."

The piece has been branded a publicity stunt by critics. "It is the most fatuous piece of work I have ever seen in a major museum," said David Lee, former editor of Art Review.

Barbara Windsor, the actress who played a prominent part in the Queen Mother's birthday celebrations and recently received an MBE, said "The Queen Mother is a national treasure. It is very churlish to be derogatory about her, considering what she has given to the country and this wonderful age she has reached."

The Tate said the comments helped visitors to express themselves. Sheena Wagstaff, head of exhibitions at Tate Britain, said: "If it offends people, then at least it has reached them."

Press cuttings from Stop It write Now, 2000.

SHOW US YER ARSE, MA'AM

hat's the message from the Tate Gallery

SHOCKING threats to kill the Queen Mother are on display as ART in the Tate Gallery.

One of the SICK messages talks of the Queen Mum "getting sliced up" while another reads: "I'd rather see the Queen Mum's arse."

They are part of a bizarre exhibition by artist Patrick Brill on show at the new Tate Britain Gallery in London.

Thoughts

Visitors are invited to write down their thoughts on any subject and then place the cards in a suggestion box.

Brill then takes three or four out every Sunday and paints them on a wall — while the rest of them are pinned to a notice board.

Some are just innocent messages from youngsters like: "I love Britney Spears."

But others are causing a lot of offence.

One says: "The Queen Mother at 100. Why are we celebrating? Set the people free."

Another vile note says: "Hang the

By JUSTIN DUNN

Queen Mother." But the worst reads: "F*** the Queen Mother coz she got Princess Diana killed so she's gonna get sliced up.

"If you wanna help me my number's on the back. F*** the Queen by slicing her threat."

We rang the mobile phone number but it was out of service.

One of the disgusting comments Brill has chosen to paint on the wall is: "I would rather look at the Queen Mother's arse."

Visitor Mike Harrisson, from Calgary, Alberta, Canada, complained: "It's disgusting that this is called art. I can't believe how disrespectful these people can be."

Jokes

Brill claims that his exhibition challenges the idea of censorship.

He said: "I don't necessarily agree with the comments but it's a distortion not to include them.

"I wouldn't want to live in a society where you can't make jokes about the Queen Mother's bottom."

Sheila Wagstaff, head of exhibitions at the Tate, said: "If this offends people, at least it has reached them."

THREATENED: Queen Mum

GALLERY: The Tate Britain

B More historical norms of art making activity have this idea that it is a bit like education. It's a mode of thinking and activity connected with action. Art brings the possibility of inventing who you are or want to be. When you see kids making art you witness them taking control of their world. As adults most people lose all that and end up being pushed around, or they become the ones that boss others around. Anyway, after I was in Intelligence at the Tate, I did The Critics Rave in New York, which featured all the bad reviews I got from Intelligence. I made them into beer mats.

M Do you worry a lot about what people who don't know the inner workings of the art world will ever make of things like your beer mats?

B I do think about it, yes, but not in the worrying way you mean. I enjoy evolving ever more complicated structures. The difficulty comes when curators are worrying about how it will relate to the public. A lot of funding for museums comes through education budgets. So, they look at my art and think, "Oh, he does things with the public, maybe we should get him involved in this?" And it all goes wrong from there. I want to exploit the public for my own ends.

Rave, Bar room, beer mats, Printed by Purgatory Pie press, 2001

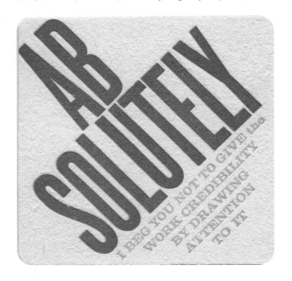

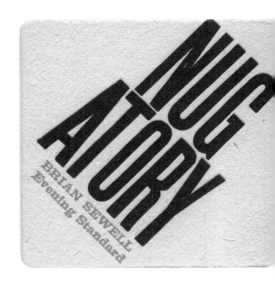

› ave, cover for Beer
ats, 2001.

also available
BOB & ROBERTA SMITH's
unPopular recurd (SIC)
WE SPY USA
The Soho Archipelago
Jesse Helms' NIGHT ATTIRE
Elvis is Everywhere

Fatuous is the new Fabulous

¡ETAL

SHOW AT THE OLD

SMITH

Bob & Roberta

WHEN

RAVE!

THE CRITICS

© 2001 F. BRILL & PURGATORY PIE PRESS

ESTHER K SMITH
editor

DIKKO FAUST
hand type, letterpress

Craw Clarendon, Rhumba, various gothic wood types

PURGATORY PIE PRESS
19 HUDSON ST #403 NEW YORK NY 10013
212-274-8228 www.purgatorypiepress.com

When these London critics
talk – we listen!

Bob Smith

VISUAL
SCRAPS
OF URBAN
PEASANT
CULTURE

BRIAN SEWELL · Evening Standard

I have eve[r]
seen in a[]
MAJOR
MUSEUM

DAVID LEE - Arts Review

Rave, Bar room, beer mats, Printed by Purgatory Pie press, 2001

ESPECI-
ALLY IN
AN ART
GALLERY

MIKE HARRISON
Computer Salesman
Calgary, Canada

THE MOST
FATUOUS
PiECE OF
WORK

NOBODY
WANTS
TO SEE
HATEFUL
THREATS

A FOUL-
MOUTHED
CANTANK
EROUS
GUERRILLA

RICHARD DORMENT
-Daily Telegraph

I AM LOST IN ART

10p Print, Jeffery Charles
Gallery, 2002.

POINT

5

LESS

objects with no meaning

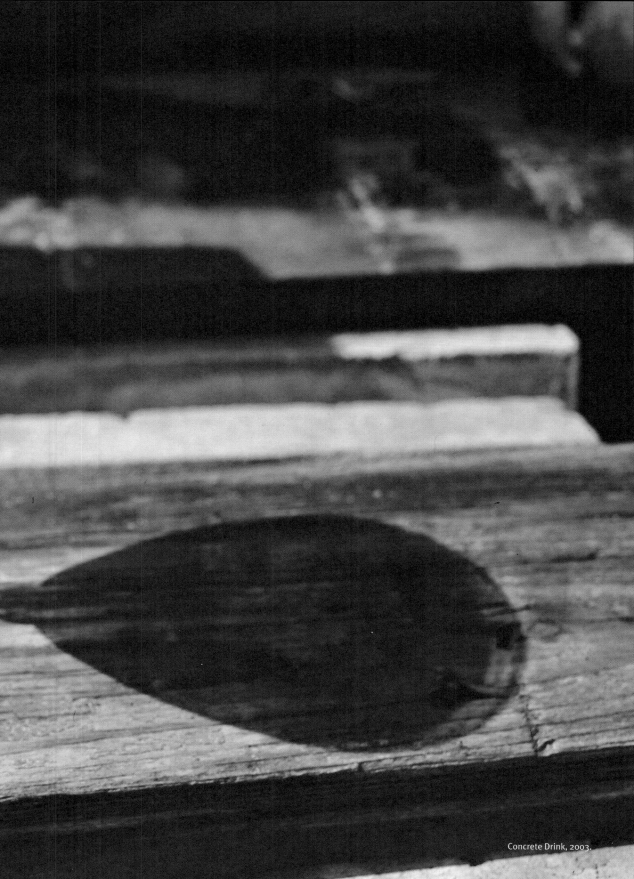

Concrete Drink, 2003.

objects with no meaning

M The pointless object with no meaning – that's like a definition of conceptual art for people outside the banquet.

B Yeah, this is freedom in a weird way. I spoke to Nam June Paik about his work once. I got all wrapped up in trying to second guess him and throw his work back to him as a question. He just said his work had 'no meaning'. I know, being from the West, I should have read that as a Zen Buddhist statement, but it's actually really good for art to have no meaning.

M No meaning in this sense means no prescribed or already known meaning?

B Well, it doesn't mean no meaning in any sort of religious sense. There is a side to me that thinks of things in an absolutist way. But making things out of nothing and them having no meaning are both important to me. I am making a 'matter maker' at the moment, which is a suitcase I don't put anything in. At the end of each week I peek inside. And the reason I've used vegetables a lot was that they seem to be beyond any kind of meaning. After all the long stories about potatoes, in the end you're still stuck with a potato.

M Do you think the reason you aren't a favourite of *The Guardian* art review pages is, well, you seem undignified?

B Blimey, Matt, I thought they loved me. There's a kind of pluralism to my making things and doing lots of different things, that maybe puts *The Guardian* off. There are lots of competing contradictory ideas. When I started out making art I thought that was a real problem. Now I embrace it. It's a complex and busy business, my art making and my strategy for making art. It's not single-minded and I avoid being professional. Anyway, I'm an *Independent* reader. I don't like *The Guardian*, not because of Adrian Searle, but because of that fat idiot New Labour apologist David Aronavitch.

Blimey

Concrete Surprises, **>**
2002.

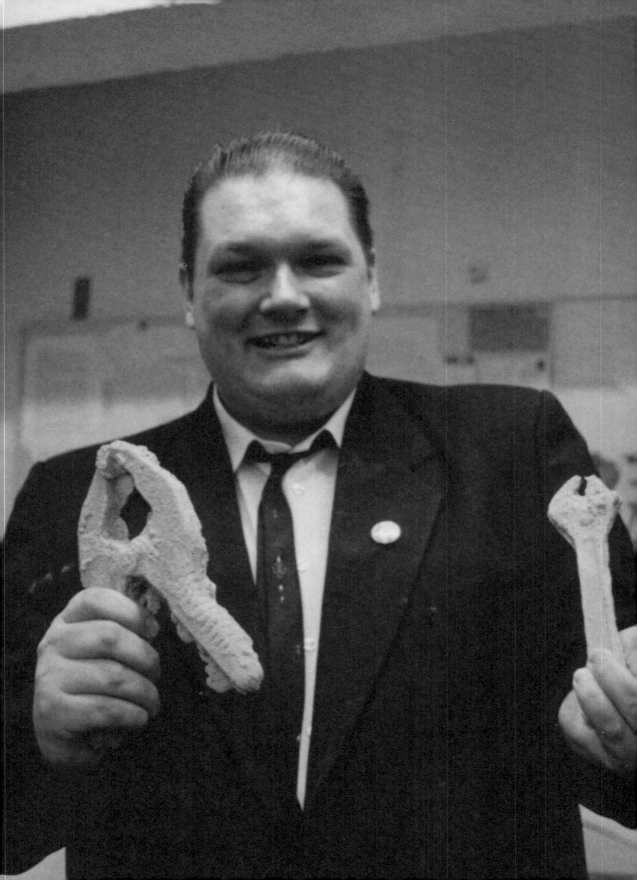

M There are many models for what you're talking about, all sorts of Kippenbergerish types in whom you could possibly see only pranks and silliness, but somehow they're given a place in the hallowed pantheon. Kippenberger himself seems continually on the ascent now he's dead. Considering his reputation it's surprising that until relatively late in his life he wasn't at all a must-have artist in modern art museum collections. Now he's become Courbet, someone tragic and marvelous.

B Being dead worked for Kippenberger, whereas it's been a pile of shit for Beuys.

M When you propose as art some gags about "Cockney wankers" or "up north" etc., we understand those words very well. Most of us don't read German so with Kippenberger's gags a lot is lost on us.

B The Germans, although ridiculed for having no sense of humour, have the best humorous artists.

M But once they're in the art hall of fame the low aim is no longer discussed so much. With you the aiming low is always noticed. I suppose it's because you yourself insist on it. It's a bit of a tic on your part. You keep going for that.

B Fundamentally it is who you are. I am a flawed individual. Part of my work – this may seem too honest in a way – is to look at my problems and not make excuses. The work I made about ten years ago was about the problem of the business of making art being a bit humiliating. It was about trying to get my art out there. Getting people interested is humiliating. I was trying to expose the frailty in the production of art. Maybe it's quite sentimental, my love of art, and then all the problems with it. I want to embarrass me in order to embarrass you. That's my tic.

M I wonder if it isn't too much to ask of people seeing a photo of a turnip in a gallery that they should strain to believe that something profound is going on.

◄ Dick Skum, Leadsinger of
Armitage Shanks, Poses
with plaster tools, 1999.

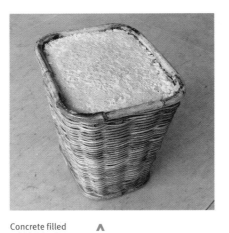

Concrete filled
rubbish basket,
2002.

Painted Carrots,
1997.

Parsnip painted to
look like a carrot,
1997.

Concrete Boots,
2002. Λ

Λ Shoes filled with
concrete at the opening
of Artists Are A Bunch Of
Cowards, The Collective
Gallery, 2002.

B I wouldn't say that. The vegetable works are trying to confront Buddha with a parsnip, and I am holding it up to the Buddha and saying, "No, I don't think so, but maybe." It's a sort of inconsequential activity. One of the big problems, or questions, with my work is this idea of the surface. You do something that has implications that are quite profound. Lots of artists go straight for the profound idea. But my thing is to make things to highlight what's going on underneath, without trying to identify all the time quite what that underneath thing is.

M For a general audience all conceptual art is inconsequential and pointless until somebody justifies it and, then, the audience has the option of saying "I see, it's about stopping the war in Vietnam", or "I see, it's about exposing the world as a set of ideas." But you keep telling them not only does it appear inconsequential, but inconsequence really is its aim. If fact, there are layers of more and more inconsequence.

B Yeah, but there's a meta-space that you can enter. To understand that life in general and all these profound thoughts are incredibly inconsequential anyway is to understand a truth. Carrots are painted beige and parsnips are painted orange. That becomes central to people's thinking, just like whether to vote Labour or Tory seems important at the ballot box.

M In the 70s a few hippie art people with sideburns were prepared to believe a lump of lard on a chair was as important as Jim Callahan saying something about whatever was going on in British politics at the time. But Beuys has this beige and brown visually tasteful quality, tasteful at a not particularly high level, but maybe that's exactly the right level for him. Anyway, there's an elevated tone to him, to his legend. Whereas you, on the other hand, want to let us know that there's always going to be this de-elevated tone to everything you do. But you want to claim, almost in a stoner kind of way that well, maybe, there is also a meta-space, a space for something dignified to be happening.

◀ Rubber Chops, 2001

ARTISAN

YOU THERE
MAKE YOUR
OWN DAMN
ART.
DON'T EXPECT
ME TO DO IT!

FREE PRINT

GREAT ARTISTS
Wee Wee artists
Lazy artists
Genius artists
USELESS ARTISTS
Easy Going artists
UPTIGHT Artist
ARTist
ARTISTS

... the idiot is not an idiot.

B I'm hoping there's a meta-space in there for that. But what I'm also saying is "Bob Smith is like The Good Soldier Schweik". Schweik is the idiot/hero in a brilliant novel by Jaroslav Hasek. The story never gives away that the idiot is not an idiot. It's a subtext, and that's also the same in Gogol's writing. Nowhere is the joke given away. The 'good soldier' gets out of being sent to the Front because he's so ludicrously stupid and he does his job so badly that nobody will send him there.

He doesn't get involved with the big battles of life and death, but he does stay alive. And you're left wondering whether this is a calculation on his part or whether he's a complete idiot. The inference is that it's a calculation, but you still don't want to believe it. You want to believe that he is an idiot. That's part of the reason for having Bob and Roberta Smith. Obviously when I say Bob Smith I mean Bob and Roberta. But the whole thing is for them to be seen as fictional, fictional idiot savants.

Concrete filled shoes, 2002.

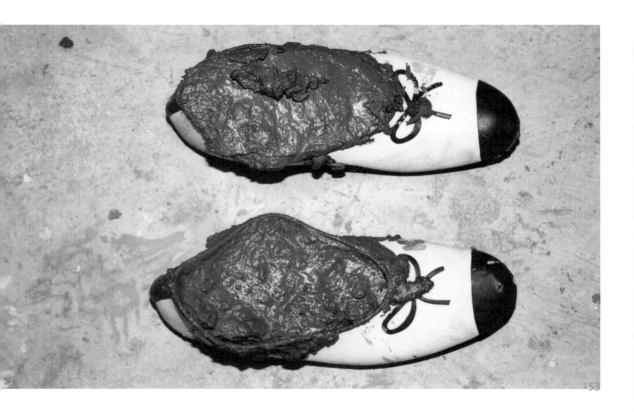

I AM
OF BE
ARTIST
WANT A
A POP

SICK
NG AN I
TO BE
STAR

art and music

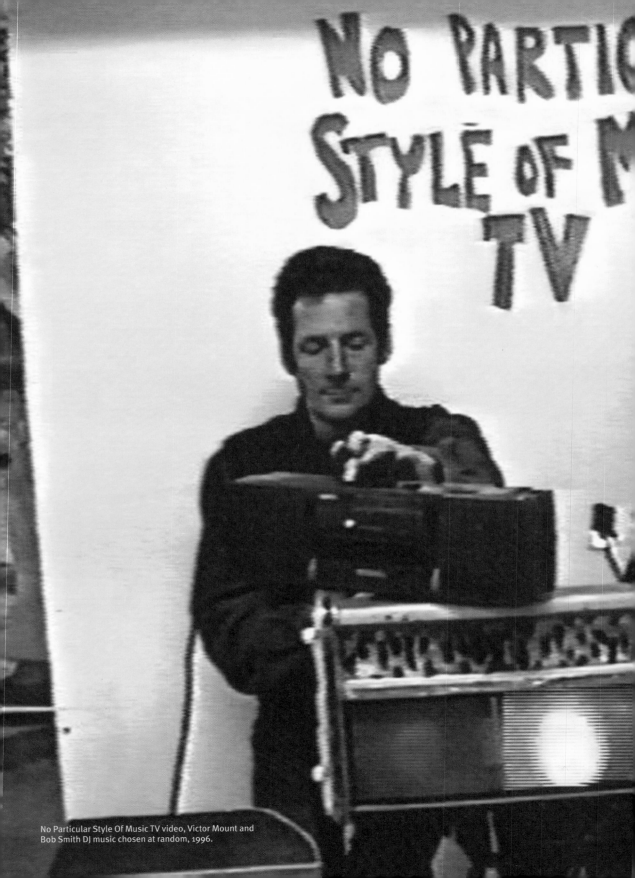

No Particular Style Of Music TV video, Victor Mount and
Bob Smith DJ music chosen at random, 1996.

art and music

M You have your band, The Ken Ardley Playboys. I suppose the reason pop music has a place in what you do is that it's popular – you're interested in the difference between the weirdness of art and the normality of anything popular.

B I also love this idea that in the 60s things went from buttoned-down Joe Meek – everybody wearing suits – to the end of the 60s and everybody wearing floral shirts and big ties and fur coats. I love that change because I think the same difference is there between my mind and the real world. The early 60s is the exterior – the real world – and then my mind is like a big Flower Power place. Everything in life is calibrated on that kind of journey. If you have to go to the dole office or work that morning that is a 1961 mode to be in. But then in the studio there will be loud music and hanging out and naked women and Jimmy Hendrix. A lot of the music I make has that going on in it.

M Is the music side always fun or is there something grinding and horrible and, hell, you wish you'd never started it?

B Well, actually, this morning I was yelling at Jessie, "The fucking Ken Ardley Playboys have stitched me up again!" 'cause I'd booked a studio and Sandy and Ken couldn't come. I phoned up Sandy this morning and his wife told me he was in Istanbul! But, then, he's only the drummer.

M What about the others in the band?

B I don't know what they think about it, but for me it's all tied up in self-indulgent reverie about being in a band. Probably for them it is as well. It becomes an irritant and then when that happens you do something on your own. And you really enjoy that. But then you go back to the band. The attraction of it is that you can only do it with all of these people. You either make it work or else it fails. It's very interesting because if you're an artist most of the time you don't experience that – you sit in your studio for months constructing something and then, even if no one gets it, it's invulnerable. Playing music can all go wrong. But when it all goes great it can be a real buzz.

The Ken Ardley Playboys performance recreating the Beatles famous Let It Be concert on the roof of the Bank Gallery is thwarted by bad weather. Part of The Charge of the Light Brigade, Bank, 1995.

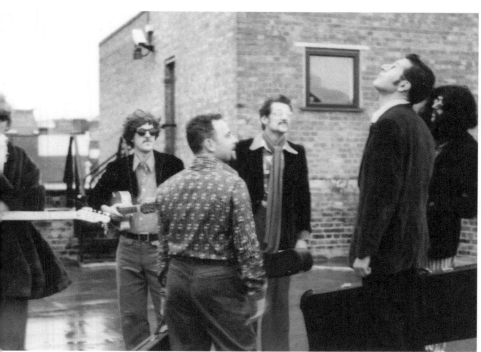

M The band has a funny name and has gone on for years and years. It's half about deconstructing rock and roll, but in order to do that you've got to be half into the rock and roll thing too. You have to have the anxious nerves before you go on, and you have to pray that it will all go well. Then, afterwards, you're tired, elated or self-hating.

B It's the real self-hatred that I really like. I was thinking lately about Ian Curtis and Joy Division. He did these amazing performances because he manifested this idea of being really scared and really angry at the same time. When he's performing you've only got Ian Curtis there, he's completely 'naked' on that stage. That never happens with artists. Even at an opening you don't have a sense that this person has painted these paintings or made this thing. When a musician is playing there's a sense of something actually happening.

No Escape From The
Beatles, 2002.

Victor Mount and
Sandi Topic wait for
help in a car park in
Norfolk after the Ken
Ardley Playboys tour
bus brakes down,
1996.

Gauguin Is A Hippy,
Lyric sheet, 2004

· GAUGUIN IS A HIPPY.

HE GOES TO ALL THE HIPPY
BARS.
HE HANGS OUT WITH
ALL THE STARS.
SHE WENT TO TAHITI
HE GAVE ALL THE
WOMEN VD.

we aren't 17

M The unreality element is it's one amongst many things you do, and you aren't in that situation of the hungry rocker who only knows one thing, who's trying to get a record deal – all your hopes and reasons for living aren't focused on that. You've almost designed your music act so it focuses on disillusion more than illusion.

B Well, it has its own reality which is our reality of 'the band'. But I agree with what you're saying, we aren't 17 trying to make it as a band. But we are equally sad, in a way, because of still enjoying doing it. The only thing to do is to carry on. When you've got five people and no one can make the decision to stop and nobody really wants to stop…. They might not want to do anything for 18 months, but they still want to do it.

M Do you get any better?

+ PS. At last!
We are recording the Rock Opera
on the 6 + 7 of December!

THE KEN ARDLEY PLAYBOYS *We've Got Ken*
CD (LUCKY GARAGE RECORDS)
These guys come from the same gene pool that spawned
Thee Headcoats and Armitage Shanks, and, like them, should
be considered among the best in the UK. No doubt people
will compare this band to the Fall, not a bad thing at all,
depending on what Fall material you're referring to. Ken's
voice recalls Mark E. Smith's famous whine and (sometimes)
growl, which is what first grabbed my ear, but after repeated
listenings, it's obvious that the Ken Ardley Playboys have a
lot going for them on their own merit, all comparisons aside.
Loose "pub rock" that inspires one to play this repeatedly, if
nothing else. I'm looking forward to the day when I'm pissed
drunk in a bar, and the Playboys are on stage. It has to be a
great experience, I envy anyone in London who can just bop
down the corner on any given weekend and check them out.

HELLO BOB,

I THOUGHT YOU MAY HAVE MISSED
THIS REVIEW IN THE AMERICAN PUNK
ROCK/DRAG RACING PUBLICATION "GEARH
(ISSUE #6).

ALSO, YOU MAY BE INTERESTED TO HE
THAT OUR ICA PERFORMANCE IS TO B
REPEATED AT "ABSORPTION" UPSTAIRS
@ THE GARAGE. 20/NOVEMBER.

YOURS,

Standing

Dear Steve,
Have you seen this review? We played a great gig up the Lad
recently with 'Planet of the Apes'. We're playing in Bristol at the Arnolfini
at the 12th December hope you will all be
at the gig... oh we can have it best Bob.

B No, I think we've got worse.

M Does anyone in the band get technically better? I've always thought it was
 extremely good and structured. I think your new solo record is excellent.
 But, well, do you find by playing together you can make chord changes
 faster or, you know, be more amazingly knowledgeable about scales?

B No. With the solo project I worked with this guy, a saxophonist, George
 Clegmore, who has played in fantastic jazz bands and we really gelled and it
 really worked. He plays these beautiful melody lines that no one in the band
 could do... and I realized, in a way, The Ken Ardley Playboys just don't gel. A
 lot of it is just about personality. Magic. But there is none of that. It's all
 awkward sideways glances. With the Playboys it's always a sand-papery
 difficult relationship. It is its own idiotic *cul de sac*. Only one of them really
 knows how to play his instrument, that's Graham Revell. However, The
 Playboys' sound depends on incompetence.

▼ Rubber pies, 1996

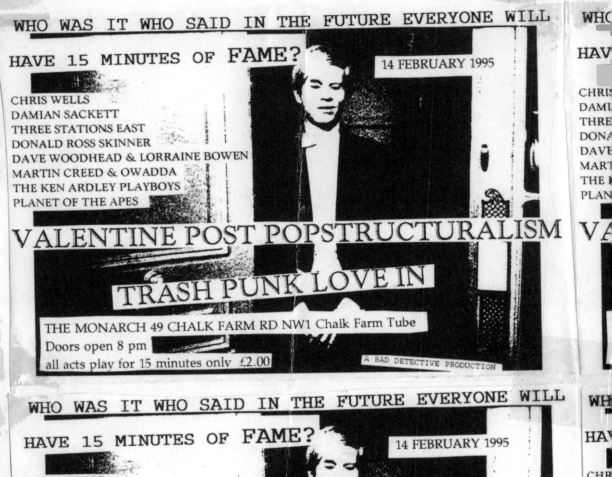

WHO WAS IT WHO SAID IN THE FUTURE EVERYONE WILL

HAVE 15 MINUTES OF FAME?

14 FEBRUARY 1995

CHRIS WELLS
DAMIAN SACKETT
THREE STATIONS EAST
DONALD ROSS SKINNER
DAVE WOODHEAD & LORRAINE BOWEN
MARTIN CREED & OWADDA
THE KEN ARDLEY PLAYBOYS
PLANET OF THE APES

VALENTINE POST POPSTRUCTURALISM

TRASH PUNK LOVE IN

THE MONARCH 49 CHALK FARM RD NW1 Chalk Farm Tube
Doors open 8 pm
all acts play for 15 minutes only £2.00

A BAD DETECTIVE PRODUCTION

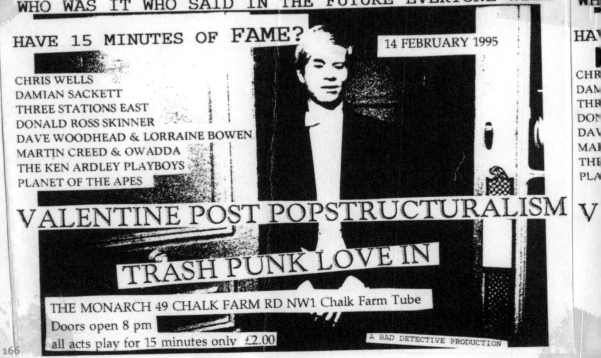

WHO WAS IT WHO SAID IN THE FUTURE EVERYONE WILL

HAVE 15 MINUTES OF FAME?

14 FEBRUARY 1995

CHRIS WELLS
DAMIAN SACKETT
THREE STATIONS EAST
DONALD ROSS SKINNER
DAVE WOODHEAD & LORRAINE BOWEN
MARTIN CREED & OWADDA
THE KEN ARDLEY PLAYBOYS
PLANET OF THE APES

VALENTINE POST POPSTRUCTURALISM

TRASH PUNK LOVE IN

THE MONARCH 49 CHALK FARM RD NW1 Chalk Farm Tube
Doors open 8 pm
all acts play for 15 minutes only £2.00

A BAD DETECTIVE PRODUCTION

WHO SAID IN THE FUTURE EVERYONE WILL

NUTES OF FAME? 14 FEBRUARY 1995

AST
NER
& LORRAINE BOWEN
OWADDA
PLAYBOYS
ES

INE POST POPSTRUCTURALISM

RASH PUNK LOVE IN

CH 49 CHALK FARM RD NW1 Chalk Farm Tube

pm

r 15 minutes only £2.00 A BAD DETECTIVE PRODUCTION

WHO SAID IN THE FUTURE EVERYONE WILL

NUTES OF FAME? 14 FEBRUARY 1995

AST
NNER
& LORRAINE BOWEN
OWADDA
PLAYBOYS
ES

INE POST POPSTRUCTURALISM

RASH PUNK LOVE IN

RCH 49 CHALK FARM RD NW1 Chalk Farm Tube

3 pm

for 15 minutes only £2.00 A BAD DETECTIVE PRODUCTION

Are You Sitting Comfortably ?
rcafe 6pm Friday 9th May 2003

Bob and Roberta Smith.

and a piano

Flier advertising, First public performance of
Bob and Roberta Smith Solo career at the
Royal College of Art, 2003

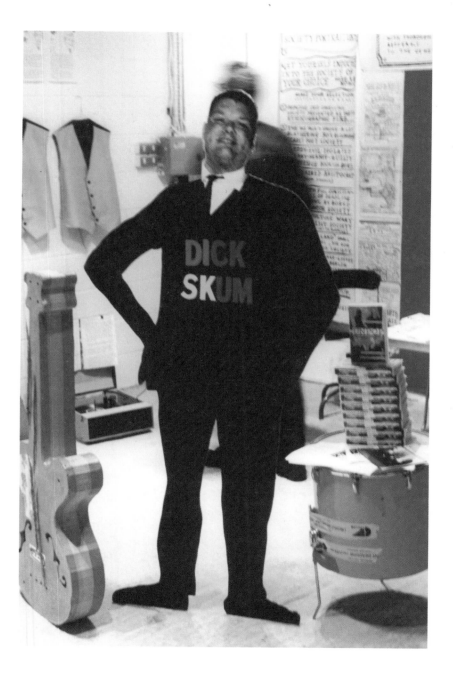

▼ Cut out of Dick Skum, lead singer of the Wonderful Armitage Shanks at the launch of Unpop, Anthony Wilkinson Gallery, 1996.

2NITE!!!

'MIKE DAWSON & ROBIN NATURE-BOLD' PRESENT:

'THE DIFFERENT SO... MEN GIG,
MANCHESTE... 3'

FEATURING:
(FOR THE FIRST TIME IN MANCHESTER'S HISTORY)

'BILLY CHILDISH &
THE BUFF MEDWAYS'

WITH SPECIAL SUPPORT BY:

'EDWARD BARTON & SONS'

ALSO APPEARING:

'BOB & ROBERTA SMITH & PIANO'
~~(WITH GRAHAM REVELL & SAXOPHONE)~~

ON:
S...003

AT:

Backed to...
the 'HILT'...

FLUX
magazine

UK.

...BLE FROM
...STREET
...CHESTER.

...£11)

'WILL
ANY OF
THE BEATLES
MAKE IT TO
64?'

ANTHONY WILKINSON & UNPOP PRODUCTIONS
are delighted to invite you to the exclusive presentation of

UNPOP
THE VIDEO
Saturday 3 June 6-8.30
featuring, The Ken Ardley Playboys
Matthew Collings with Interspecies Love Child,
Dick Skum & Sharp and Martin Creed & OWADDA
filmed at the
Ding Dong Twist Club's Ninth Anniversary Gala Evening
wide screen entertainment, pies, cocktails, and
'unpop' at a introductory price of £7.00 will be available
at Anthony Wilkinson Fine Art
Henrietta House Henrietta Place (entrance Welbeck St)
London W1 tel 081 986 3034

'ON THE DOOR'

< Flier for gig at Matt
and Fred's,
Manchester, Give
away Badge and flier
for Unpop, 1998.

Fliers for our first V
open air gig as part
of Joshua
Compstons, Fate
worse than Death,
1994.

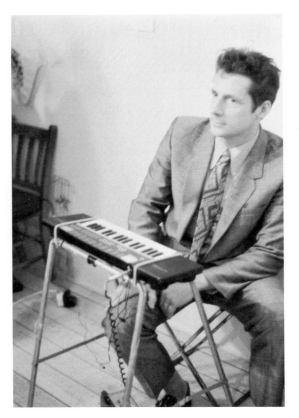

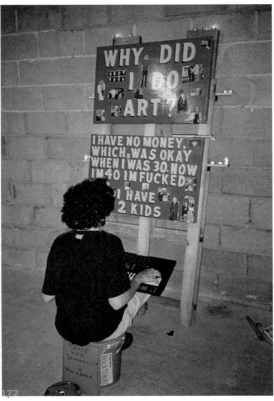

WHY DID I DO ART?

I HAVE NO MONEY, WHICH, WAS OKAY WHEN I WAS 30. NOW IM 40 IM FUCKED I HAVE 2 KIDS

To THE ELECTORS of FOLKESTONE
VOTE
BOB SMITH
FOR MORE ART

BEING AN ARTIST I SHALL KEEP AN EAR OUT FOR THE RATES MORE ART NOW.

I will build **FIVE** New Museums in SHEPWAY **DEVOTED** to ART. **1.** THE MUSEUM of WHAT'S OUTSIDE. A GRAND MUSEUM DEVOTED TO HOUSING EVERYTHING NOT NORMALLY IN MUSEUMS. **2.** THE MUSEUM of THE FUTURE. A MUSEUM OF ARTEFACTS THAT DO NOT YET EXIST. **3.** THE MUSEUM of Art NOW, A MUSEUM OPEN ONLY IN THE AFTERNOON WHICH WILL EXHIBIT ART MADE THAT MORNING. **4.** THE MUSEUM OF THE CONTROVERSIAL A MUSEUM OF ALL that is SHOCKING And FINALLY **5.** THE BORING MUSEUM DEVOTED to ART that is DULL and WORTHY of NO REAL INTEREST to ANYONE WHAT EVER IT IS BOB SMITH IS IN FAVOUR OF IT.

if **I AM ELECTED**

• the EAST CLIFF will be the NEW WESTERN BEACH • FOR TOO LONG IT HAS BEEN POSTPONED THE **DECLARATION** of FOLKESTONE as 'CITY OF YOUTH'. **BEWARE of FISH**

THE FOUL AND PERFIDIOUS FISH INVADES OUR WATERWAYS! FISHERMEN OF ENGLAND DRAG THEM SCREAMING FROM THE RIVERS! I DO NOT SEE THAT WE NEED FISH AT ALL WHEN WE HAVE PLENTY OF GOOD ENGLISH MEAT. HOW DO WE KNOW WHAT THEY ARE BRED? MAYBE IN GERMANY OR FRANCE OR EVEN THE NORTH POLE. FISH ARE OUR NATURAL ENEMY. WE KNOW THIS MANY OF US, AT A VILLAGE LEVEL, TO BE TRUE. WONDERFUL ART, VILLAGE ART, RURAL ART, TOWN ART, CITY ART, Flunkeyvanns, Monkeys, and Monkeyesses, Thieves, Thievesses, Sprites, Frights, Trumpers, Suppers, Minims, Dominions, Spirits, water-proof, under-proof, water proof, Happy Mediums, Unhappy Mediums, Spirit Rappers, Sappers, Minors and Majors, Sharps Flats, Naturals, Unnaturals, Shadows of light hues, of dark hues, of no use at all, &c. ad libitum YOU WILL MAKE ART.

PAINT FOR ALL!
join BOB AND ROBERTA SMITH for a
GRAND DAY OUT
Saturday **30th OCTOBER 2004**

on the beach in front of THE METROPOLE, the LEAS, FOLKESTONE AS PART OF NAVIGATING HISTORY WWW.NAVIGATING-HISTORY.NET A SERIES OF COMPETITIONS AND EXPERIMENTS FOLLOWED BY A CONCERT OF TWENTY SONGS SUNG BY **BOB SMITH** COMPOSED UPON THE PIANO. 12 NOON: LOCAL ARTISTS V CONCEPTUAL ARTISTS DOWN FROM LONDON MAKE A PAINTING OF THE SEA. TO BE JUDGED BY POPULAR VOTE AT 5 PM. 1 PM: LUNCH BRING YOUR OWN PICNIC. 3 PM: 'HILLS ARE THE NEW HOLES' WHO CAN DIG THE DEEPEST HOLE PRODUCING THE HIGHEST HILL IN 15 MINUTES. **3.20 PM. LOCAL POLITICANS TAKE A RUNNING JUMP.** LOCAL POLITICIANS FROM ALL PARTIES ARE INVITED FOR TO PARTAKE IN A LONG JUMP COMPETITION. 4PM. VEGETABLE PORTRAIT BUST SCULPTURE COMPETITION. VISITORS ARE INVITED TO MAKE A PORTRAIT OF IMPORTANT LOCAL FIGURES USING VEGETABLES. 4.30 PM. THE ANNOUNCEMENT OF WINNERS AND LOSERS FOLLOWED BY THE UNVEILING OF THE STATUE OF YOUTH. 5 PM. RETIRE TO THE METROPOLE TO HEAR BOB SMITH PLAY AND SING 'MY HUSBAND THINKS HE IS A MUSICIAN' AN ODE TO CHARLIE BANKS AND OTHER SONGS INSPIRED BY THE LOCAL STUDIES COLLECTION OF THE FOLKESTONE LIBRARY. 6 PM. STROLL ALONG THE SEA FRONT HOME OR GET THE TRAIN BACK TO LONDON.

VOTERS MAY VOTE FOR JUST ONE CANDIDATE.
BOB AND ROBERTA SMITH

1. IN WHICH MID WESTERN STATE CAPITOL DID RICHARD NIXON DELIVER HIS I HAVE A DREAM SPEACH?

2. WHAT COLOUR DID PAT NIXON REPAINT THE WHITE HOUSE?

3. ON WHAT ITALIAD BEACH DID NIXONS WAR HERO BROTHER DIE?

4. AS THE SECOND MRS NIXON WHEN DID JANE ROSSELL get tHROUGH HER HEALTH CARE REFORMS?

Horis

5. WHAT ROLE DID GHERERS THE CAT PLAY IN NIXONS BID FOR THE WHITE HOUSE?

WHEN TEDDY NIXON DROWNED ALL THOSE THENAGERS WHAT WAS IT IS EXCUSE?

HOW MANY DRYCLEANINGS DID IT TAKE TO GET NIXONS SPEARM OFF OF DEBBIE HARRES WIG DID THE

WHEN WHRHOL MADE LOVE TO LOUISE BORSCOW THE PULLED HIM IN HARD WITH HER FIGHT LEGS

HE
E
BUILD
RUINS
DEMO
7

L P
THE
OF
RACY

can art change the world?

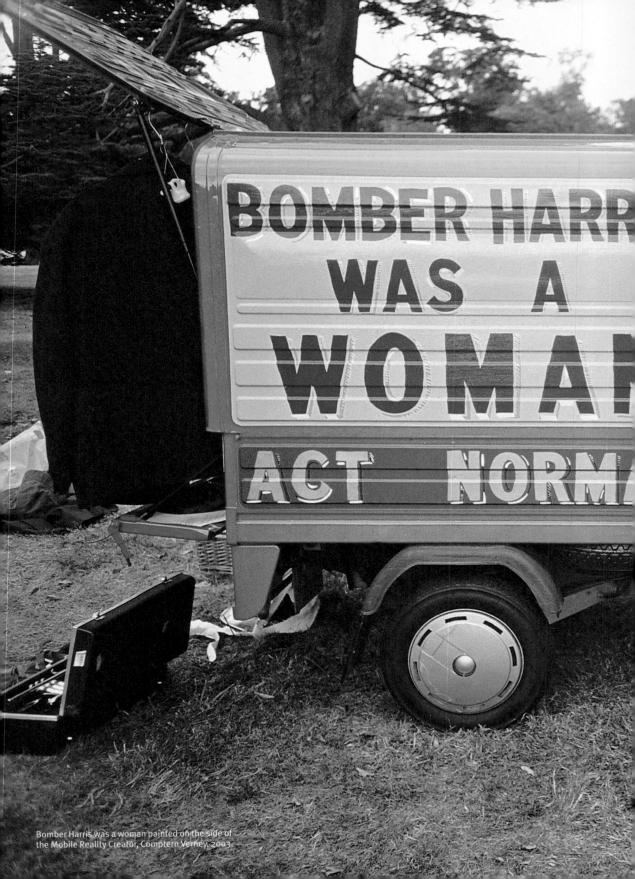

Bomber Harris was a woman painted on the side of
the Mobile Reality Creator, Compton Verney, 2003.

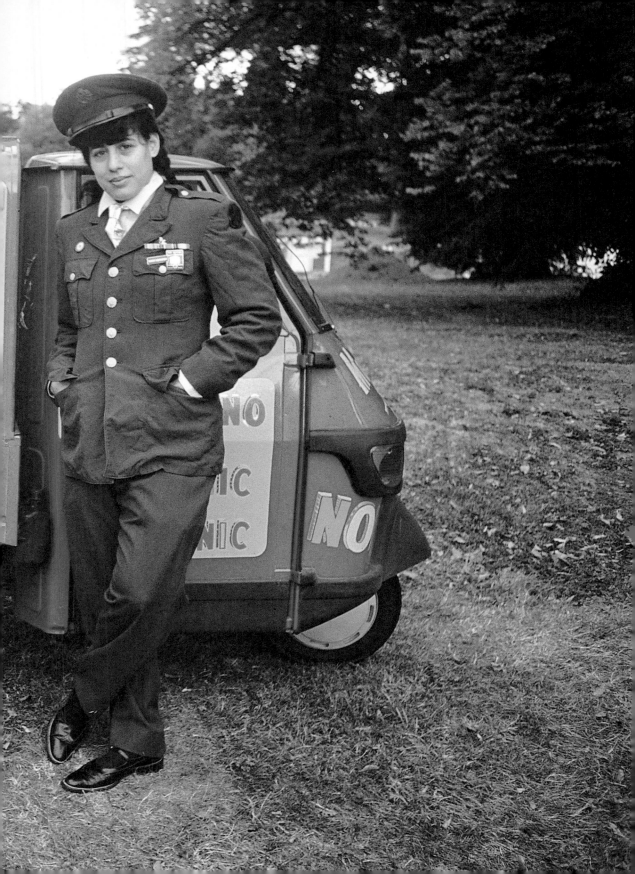

7 can art change the world?

B The idea of The Bremen Conference is based on some text works where I have characters from history, from different periods, having trivial arguments with each other, and things happen to them that couldn't possibly have really happened. So, the idea is to have a conference, rather like the Yalta Conference, where at the end of the Second World War teh Allies decided how they were going to divide up Europe and how we were all going to live. In this case I have a mixture of politicians and artists and musicians to map out the world and say what they think about the big questions of now. I gave it the incredibly profound title of The Bremen Conference. Decisions would be made at the Conference and we'd have to act on them. Women play all the parts, to parody the idea of history being made by 'great men'.

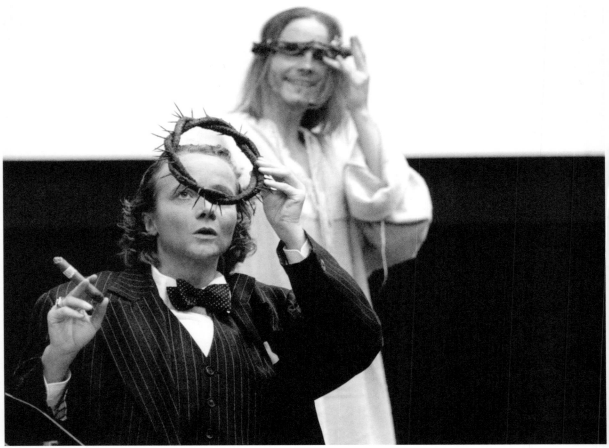

▼ Sir Winston Churchill and Jesus try on crowns of thorns, The Bremen Conference, 2003.

LA DI DA FEED THE POOR. LA DE DA CHANGE THE WORLD.

10p print, Jeffery Charles Gallery, 2002.

THE LABOUR PARTY ARE WEASELS AND VIPERS, FORKED TONGUED TURNCOATS WHO HAVE SPATTERED BRITISH PEOPLES FACES WITH BLOOD

M The last Documenta was about how art could change the world. It was about Post-Colonialism. There were documentaries and instalations, and nothing was allowed in without an obvious socially redeeming meaning. There are various layers of cynicism one could have about this whole situation. I mean, everything was socially redeeming, but looked horrible, it was aesthetically un-redeeming. But, obviously, the people involved in that show were not cynical and the people who loved it and were its apologists all felt that, at last, this powerful exhibition is going to do something worth doing. And now you're coming along and laughing at them for their ideals.

∧ The Labour Party, 2003.

... laughing at them for their ideals.

The Government, installation view, Cell Project Space, 2003.

B I am totally ridiculing them. Here's a quote: "Artist's launder guilt through art they call socially engaged just like crooks launder cash." I'm really talking about myself. By constructing a socially engaged art you're not actually helping anybody in the Third World. It's just a Western, internal dialogue concerning justification. In fact, it allows more evil to go on through so much navel-gazing. It negates real politics because it substitutes hand wringing and accusation for activity. For instance, with the left in America, you have Ralph Nader standing against Bush after he completely fucked up the last election when all the liberals voted for him and split the Democratic

The Guardian is shit,
Cell Project Space,
London, 2004.

vote. The absolutist mindset in any political situation where you really believe in your cause and ram it down people's throats – there is something admirable about that, yes, but there's also something blinkered in ignoring the wider picture. You need people like that because in the end they're the ones who are energised to put ideals into action. But the problem with this for art is that the art doesn't really have any agency in that kind of world. The thought of visiting an art show in the West and coming away thinking, "Wow, that really addressed some issues" is stupid. On the other hand, the only art worth doing is political art. It was good setting up The Bremen Conference because it was about convincing people of the politics of it in a very straight way. I sat there with all these German actresses and talked about patriarchal history and how there are only a few women in the Bremen parliament and how we're going to turn it around. What was really good was all these people came from the theatre to the performance, and the actresses had improvised all these arguments. At one stage Jesus gets cross and shouts "Ah, all the fucking Jews and fucking Palestinians, we ought to just give them arms and get them to shoot each other!" And, then, Kippenberger says "Well, that's what we are doing aren't we?" And, then, Jesus holds the cross like a machine gun and guns everyone down. It had some great moments, but generally the theatre-goers were horrified.

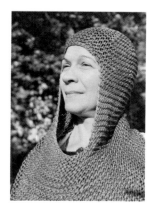

Henry The V Was A
Woman, 2003

M Er, why?

B They couldn't deal with the stupidity. I just loved it. It was on such a grand scale. It had good things to say. I mean, generally, there are usually only two women in a play and here were all these actresses who don't ordinarily get to work together. There were interesting things coming out of it, which I couldn't have foreseen, which is always good.

M So, you could say with The Bremen Conference that politics with a small 'p' I'm doing rather effectively, but politics with a big 'P' I'm kind of trashing?

... bomb the family chip shop.

B I think it's with the small 'p' politics that you can effect change as an artist, whereas maybe the problem in dealing with global affairs is it just becomes vacuous. Art tends to do you good on an individual level and then you might move on to do interesting things. The Eileen piece, for the Baltic show, is a story about this friend of mine growing up in Belfast, and is really harrowing actually. This is the most serious piece I've ever done. Basically, it's a series of concrete panels with text about how she grew up in Belfast in a Protestant family, and then, the UDA fire-bomb the family chip shop. Then they all come around in their balaclavas and sit down in the living room saying they want protection money. Then, she's told she's adopted and she goes to find her biological mother, who it turns out is English, and her dad is possibly Catholic. Her birth mother turns out to be a complete racist who was married to somebody in the army during Bloody Sunday. They move 38 times in 37 years to avoid the repercussions. So, it's a story of the stupidity of prejudice.

M Are you experimenting with a grim hectoring mode?

B As my work has gone on, the focus has got more self-righteous and politically straight, which is a bit frightening... but I'm reveling in it for the moment. So, Eileen and The Guardian is Shit and the pieces insulting the New Labour cabinet, all have an edge and urgency that the earlier pieces never had. Trying to attack something more serious gives the work more power. It means that the "soiling one's own nest", or "pissing on your chips" aspect becomes more nihilistic.

M The consistency in your work is that you're always at some level experimenting with the problem of art's place in society and politics.

B I'm experimenting with structures of democracy, democratic thinking, and the problem of how we live at a time when democracy is under threat.

M Yes, surprisingly, 30 or 40 years after they fought all those battles and so many problems were solved, and we grew up taking the new freedoms for granted, now we suddenly notice they're all in the process of being lost.

B They're certainly being clamped down on by the very people we thought were our liberators. That is a real political issue that needs addressing. I think it can be addressed through art. SO LET'S GET TO IT.

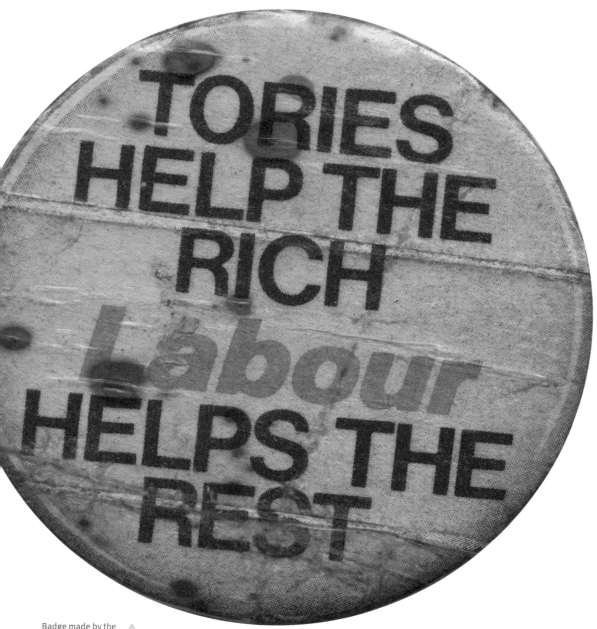

TORIES
HELP THE
RICH
Labour
HELPS THE
REST

Badge made by the
Artist for the 1979
election when
Margaret Thatcher
came to power

ART
NOT
WAR

Badge made by the
Artist during the Iraq
war, 2002

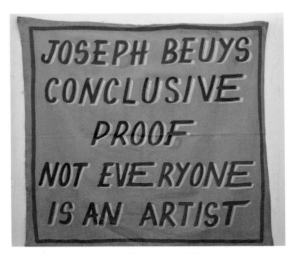

Joseph Beuys Conclusive Proof Not Everyone Is An Artist, 2002.

British Library Cataloguing in Publication Data.

A catalogue record of this book is available from the British Library.

ISBN 1 904772 24 2

Printed in the EU.

Make Your Own Damn Art
© Black Dog Publishing Limited, the Artist and Authors.

Black Dog Publishing Limited
Unit 4.04
56 Shoreditch High Street
TEA Building
London E1 6JJ
t. +44 (0)20 7613 1922
f. +44 (0)20 7613 1944
e. info@bdp.demon.co.uk
w. www.bdpworld.com

Architecture Art Design Fashion History Photography Theory and Things

Designed by Keith Sargent at immprint ltd.

Make Your Own Damn Art is generously supported by The Arts Council of Great Britain, BALTIC Centre for Contemporary Art and Hales Gallery.

Make Your Own Damn Art, is published to coincide with the exhibition Help Build the Ruins of Democracy, presented at BALTIC, Centre for Contemporary Art, Gateshead between 11 December and 3 April 2005.

Bob and Roberta Smith are represented by Hales Gallery.

ARTS COUNCIL
ENGLAND

BALTIC

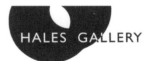

HALES GALLERY